ETCHING AND ENGRAVING: TECHNIQUE AND TRADITION

ANTHONY DYSON

Longman *London and New York*

Longman Group Limited
Longman House, Burnt Mill, Harlow
Essex CM20 2JE, England
Associated companies throughout the world

Published in the United States of America
by Longman Inc., New York
© Longman Group Limited 1986

First published 1986

British Library Cataloguing in Publication Data
Dyson, Anthony
 Etching and engraving: technique and tradition.
 1. Prints – Technique
 I. Title
 760'.28 NE850
ISBN 0-582-41347-8

Set in Linotron 202 10/11pt Plantin
Produced by Longman Group (FE) Limited
Printed in Hong Kong

Contents

Preface

There already exists a large number of books on etching and
engraving, so why write another? What is the special contribution
of this volume? The subject of prints produced by etching and
engraving is a vast and complicated one, and what follows is an
attempt to introduce the subject as simply as possible – but without
disguising its complexity. In a book as short as this, it is obviously
not possible to deal with anything in great depth; but I hope at least
to *hint* at that depth, and to provide some signposts to important
issues that cannot be treated as fully as they deserve. The
bibliography is an indispensable part of the book; in it are listed
works that will provide for the reader amplification of any particular
aspect he or she wishes to pursue further.

 In writing the book, I have tried to do several things. The first is
to provide practical guidance to some of the basic techniques of
etching and engraving. Here, as in all things, I have had to be
selective. I have chosen, for instance, to restrict my account to hand
methods, and have not dealt with such photo-mechanical techniques
as photogravure. Also, with the needs in mind of the student coming
for the first time to the subject, I have tried to propose simple and
inexpensive methods of working. The second thing I have attempted
is to offer as clear an explanation as I can of terms associated with
the crafts of etching and engraving. These are frequently
misunderstood, and the first step towards finding one's way around in
the subject is gaining a sure grasp of the meaning of these terms.
The third thing I have tried to do is to provide an historical basis for
the whole discussion. In my view, this cannot be emphasised strongly
enough. The lessons of the past are of continuing significance, even
though some of their details are only dimly remembered. In the
pages that follow, these will be brought into focus; and this effort to
link present-day procedures with earlier practice is an important
characteristic of this book. One final thing: artists who produce and
make prints from their own plates work in a rather different way
from the craftsmen who make prints in imitation of the original
paintings and drawings of others; but there are important
connections, and this book deals with both these ways of working.

Measurements of prints mentioned in the captions to the figures refer to the engraved – or etched – area ('work size') and not to the size of the plate; vertical measurements are given first. All prints are in the author's collection, or by the author, and all photographs and drawings are by the author unless otherwise stated or attributed.

Everything I have written on the subject of intaglio prints owes much to the helpfulness of Beryl Pomeroy, Marion Dadds, Gordon Nutbrown, Peter Marsh, Paula Allerton and all at Thomas Ross & Son's, the old-established firm of plateprinters. Writing this book has put me still further in their debt; they have given me the run of their premises, and also unlimited access to their rich store of knowledge and experience. I am grateful, too, to Philip McQueen, descendant of the celebrated nineteenth-century printing-house whose name he bears; he, too, has helped and inspired my study of the craft in many ways. I extend special thanks to Lawrence Josset, for many years a practitioner of the art of mezzotint; he spent hours explaining and demonstrating to me the intricacies of the process, and generously lent me a typescript containing a valuable unpublished account of this elaborate technique. Chapter 4 could hardly have been written without his help. I am extremely thankful to all those hospitable craftsmen – too many to list here – on both sides of the Channel who allowed me to photograph presses and other equipment in their workshops; to Lieve Vrancken for the gift of the mezzotint reproduced in Fig. 4.13; to Ralph Lillford, the Hogarth scholar, who has brought me so many interesting trophies, in the form of prints, from his researching expeditions; to Keith Holmes, who was so generous with his advice on cleaning prints; to Peter Thomas, of the Department of Art and Design at the University of London Institute of Education, for his usual care and promptness in printing the photographs; to Norman Binch, Staff Inspector for Art, Inner London Education Authority, who kindly read the final draft and gave perceptive criticism and advice; to those former students of the London Institute of Education whose work is reproduced here; to Wendy Smart for an efficient, elegant typescript and to Longman's staff for their careful work on the book.

My wife's patience and interest have been acknowledged by me in connection with previous enterprises of this kind. She remains unflagging in these supportive qualities – as I do in my gratitude.

A.D.
Teddington
1985

To My Parents

Introduction

ETCHING AND ENGRAVING

As verbs ('*to* etch', '*to* engrave') the words 'etching' and 'engraving' are straightforward enough. To etch is to produce pits or crevices in the surface of a metal plate through the action of acid – to allow acid to *bite* into the metal – and is a chemical process. To engrave is to produce furrows in the surface of a metal plate with a sharp tool specially devised for the purpose and is a mechanical process. Though we are here solely concerned with printing from metal plates, engraving is sometimes done on wood, and some of the illustrations to the catalogue of the Great Exhibition held in the Crystal Palace in 1851 were even printed from engraved stone.

It is when the words are used as nouns ('*an* etching', '*an* engraving') that the confusion can arise. An etching (that is, a print made from an 'etched' plate) may contain passages of engraving. Conversely, an engraving (a print made from an 'engraved' plate) may have in it a great deal of etching. Both etching (the chemical process of biting) and engraving (the mechanical process of gouging) produce crevices in metal plates; *intaglio* prints are prints made from such plates. The paper receives ink from the crevices of the plate rather than (as in relief prints) from the unbitten or engraved surface. The print shown in Fig. 1.1 was made from the plate shown in Fig. 1.2. The dark areas in the print correspond with crevices in the plate. The printing of an intaglio plate is begun by working ink into the heated metal surface and subsequently wiping it clean, leaving all the crevices filled with the pigment. Damp paper is laid on the inked plate, then – for resilience – several layers of woollen felt blanket, and the whole sandwich is passed between the rollers of a press (see Figs. 7.6 and 7.7, pp. 90 and 92). The pressure is such that the ink is transferred from the plate's indentations to the paper to produce the print, the sunken impression of the plate's edges and the raised quality of the lines being evidence of the process. You can always distinguish a genuine intaglio print from a photographic reproduction by looking for (and feeling for) this evidence.

The usual way to produce an etched plate is as follows: the

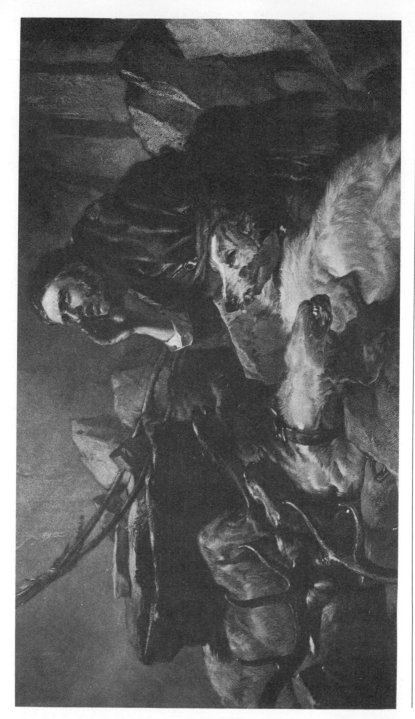

Fig. 1.1 Detail of 'The Life's in the Old Dog Yet', mixed mezzotint engraving ($22\frac{5}{8}$ in by $28\frac{5}{8}$ in) by H. T. Ryall after the painting by Edwin Landseer. Published 1865 (Ross Collection)

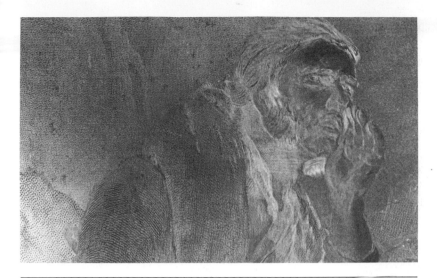

Fig. 1.2 Detail of the steel plate of 'The Life's in the Old Dog Yet' (Ross Collection)

image is drawn with a needle (called an etching point) through a thin coating of wax previously laid on the plate. The plate is then placed in a shallow bath of acid so that the lines of the drawing are bitten in. Both the extent and the depth of the biting can be controlled by successive immersions in the acid. For example, after a plate has been bitten for five minutes or so, it may be taken out of the acid, rinsed, and blotted dry. Then, certain parts of the image (perhaps passages of distant landscape) may be painted over with varnish, so that they will be bitten no deeper during the next immersion. After perhaps nine or ten successive immersions, with selected areas of the image varnished each time, there will be nine or ten different degrees of depth of crevice in the plate's surface. This is how etchings are given variety of line: the deepest crevices (that is, those exposed longest to the acid) print strongest and blackest; the shallowest crevices (those bitten for only a very short time) give the most delicate lines. Because the image is drawn through a wax ground rather than cut into bare metal, etchings can have an appearance of great freedom and spontaneity (Fig. 1.3).

Engravings, on the other hand, often appear far more formal (Fig. 1.4): their lines seem to be quite firmly regimented and to be arranged in precise directions so as to describe very clearly the solid forms they represent, and their darker areas are frequently built up by patterns of intersecting lines interspersed with dots. The engravers of former centuries who made their living by translating drawings and paintings into print developed what amounted almost to an agreed system. One nineteenth-century writer, T. H. Fielding, gives

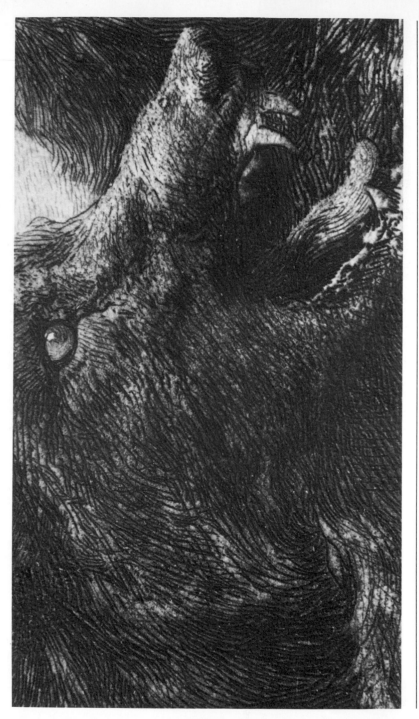

Fig. 1.3 Detail (c. $1\frac{1}{2}$ in by 3 in) of 'Baffled', an etching ($18\frac{3}{4}$ in by $27\frac{1}{2}$ in) by Herbert Dicksee, 1908

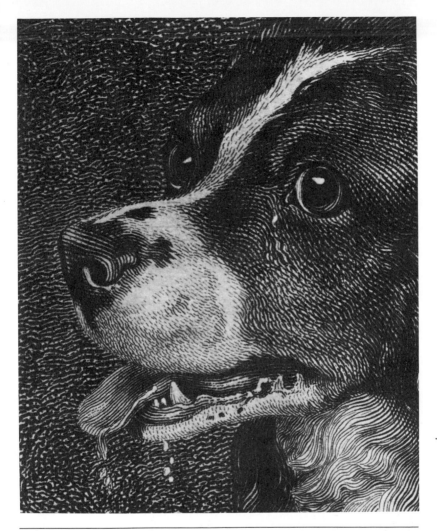

Fig. 1.4 Detail (c. 2½ in by 2 in) of 'The Spaniel', line-engraving (12¼ in by 15 in) begun by John Scott and completed by John Webb after the painting by R. R. Reinagle, RA. Published 1830

us some interesting details of this system: '. . . the graver should be guided according to the risings or cavities of the muscles or folds, making the strokes wider and fainter in the lights, and closer and firmer in the shades . . .', and he goes on to give advice on representing hair, water, buildings decayed and new, cloth of various textures, tranquil skies, and clouds (Figs. 1.5, 1.6).

The word 'etching', then, is usually associated with freedom; the word 'engraving' with discipline. But these are misleading generalisations, as we shall see.

Fig. 1.5 Detail (c. 3½ in by 2½ in) of 'The Combat', line-engraving (11¼ in by 15 in) by G. T. Doo, after the painting by William Etty, RA. Published 1848

Fig. 1.6 Detail (c. 2 in by 1½ in) of 'Macbeth', line-engraving (15¼ in by 20¾ in) by William Woollett, after the painting by Francesco Zuccarelli. Published 1770, by the engraver

AUTOGRAPHIC AND REPRODUCTIVE PRINTS

It is now time to introduce two more terms: 'autographic' and 'reproductive'. We have already discussed autographic and reproductive prints, although not in these words. An autographic print is, as the word suggests, a print produced by an artist's own hand. It is usually an original print, one made for its own sake rather than in imitation of a drawn or painted image. The etchings by

Rembrandt (Fig. 1.7) and by Picasso (Fig. 1.8) are both examples of autographic prints. In each case the artist would have worked on the plate personally, making all the important technical decisions as he went along. In fact, these particular examples underline the impossibility of making hard definitions: while we are pretty sure that Rembrandt did everything for himself, from laying the wax on the plate to controlling the acid and probably even getting involved in the printing, we know that Picasso had a fair amount of technical help from craftsmen. A reproductive print is one made in imitation

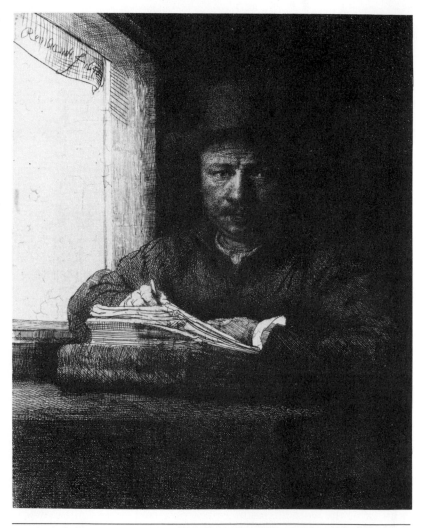

Fig. 1.7 Rembrandt van Rijn (1606–69), self-portrait, etching 1648 (British Museum, Department of Prints and Drawings)

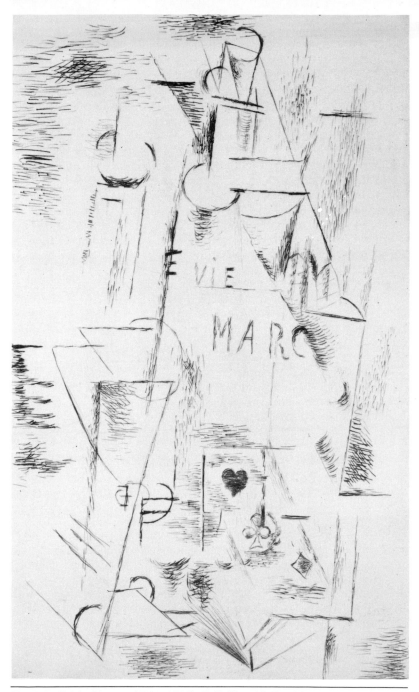

Fig. 1.8 Pablo Picasso (1881–1973), 'Still-life with Bottle', etching (c. 20 in by
12 in), 1912 (British Museum, Department of Prints and Drawings) © DACS 1985

of an original image – usually a painting. We should consider, though, that word 'imitation'. The word 'translation' has been used above, and you will see that there could be a vital distinction. In fact, there were some extremely bitter quarrels in late eighteenth- and early nineteenth-century art circles in Britain over this very distinction. When the Royal Academy was founded in 1768, those who made a profession of reproductive engraving were not admitted to membership precisely because they were alleged to be 'mere imitators'. For nearly a hundred years the engravers struggled for admission, eventually putting their case to a committee of enquiry set up by the Government in 1835. The engraver John Burnet (1784–1868) sadly told the committee that 'no attention or respect is paid to engraving in this country. The public considers engravers only as a set of ingenious mechanics'. Not until 1855 was an engraver – Samuel Cousins (1801–87) – elected to full membership of the Royal Academy. Engravers saw themselves as translators rather than imitators; and in an important sense they were, of course. Figure 1.9 shows an interesting example of a stage in this process of translation. The engraver, reproducing an original painting by Edwin Landseer (1802–73), has gone as far as he can in his work on the plate, and has made a print for the artist to inspect. This print bears chalk marks made by the artist to guide the engraver further in his effort to translate paint into etched and engraved line. In order to perform this apparently straightforward mechanical task, an engraver had to master a formidable range of skills and techniques, and had to achieve a degree of precision usually quite unnecessary (or irrelevant) in autographic printmaking.

ETCHING AND ENGRAVING PROCESSES

The words 'etching' and 'engraving' cover a wide range of processes. They will serve as convenient headings under which these processes may be arranged in two groups: chemical and mechanical. Among the chemical processes are those known as aquatint, soft-ground etching, sugar-lift and stipple engraving; and among the mechanical processes are those called drypoint and mezzotint. All these methods, whether chemical or mechanical, can be employed with freedom or with deliberation. There simply are no rules about this, apart from those an individual artist or craftsman makes for himself and apart from the influence of the materials themselves. Drawing lightly through a layer of wax is *likely* to lead to greater freedom of line; cutting into metal with an engraving tool is *likely* to demand a more calculated approach.

 We will presently describe these processes in greater detail, but it would be as well to introduce them briefly at this stage. All the chemical processes depend upon the principle of protecting selected

Fig. 1.9 Detail of 'A Distinguished Member of the Humane Society' mixed mezzotint engraving (18¾ in by 24¼ in) by Thomas Landseer. Proof 'touched' by Edwin Landseer, the artist. Published 1839 (British Museum, Department of Prints and Drawings).

areas of the plate with an acid-resistant substance – wax, varnish, resin, asphaltum, shellac, candle grease or even soap – and allowing acid to attack the exposed metal. The mechanical processes depend upon the principle of removing or displacing the metal with an appropriate tool.

Aquatint

Aquatint (Fig. 1.10) is so called because plates etched by this method produce prints with the effect of water-colour – superficially, at least. The polished plate is sprinkled evenly with resin or asphaltum, either by hand (through a muslin filter) or in a specially constructed box in which the powder is agitated and then descends like a light snowfall on to the plate. The plate is heated until the grains of resin or asphaltum melt and adhere to it in tiny globules. On immersion in acid, the areas of metal exposed between the globules are attacked or 'bitten into' and the required image is produced by successive immersions. Between these immersions, biting is controlled by stopping out appropriate areas of the plate with acid-resistant varnish. Areas bitten for the shortest time produce the palest tones; those bitten longest, and therefore most deeply, print darkest. Globules and varnish are removed with solvents before printing takes place.

Soft-ground etching

The wax used in etching is usually hard – that is, it solidifies after application as the plate cools, and can therefore be handled without disturbance. A softer wax will, however, faithfully take the imprint of a thumb or finger through to the bare metal. Soft-ground etching is a process which takes advantage of this property of soft wax. For example, paper can be laid on a plate grounded with soft wax, and pencil strokes made on the paper will lift the wax from the plate beneath. A detailed drawing can be transferred and subsequently bitten into the plate by etching in the usual way. Figure 1.11 is a greatly enlarged detail of a soft-ground etching. The pencil drawing of the sheep was made on textured paper laid over a soft wax ground. When the drawing was complete, the paper was lifted away, bearing on its reverse side traces of wax exactly corresponding to every stroke of the drawing – and, of course, leaving its exact counterpart in bare metal, waiting to be etched.

Sugar aquatint

Sugar-lift, or sugar aquatint, is a variation of aquatint. An image is brushed on to the plate with a solution of sugar and black drawing

Fig. 1.10 Detail (c. 4 in by 5 in) of a sporting aquatint, artist and engraver
unknown. Published 1840

ink. Then, a layer of quick-drying varnish is laid over the image and
the plate immersed in warm water, whereupon the sugar solution will
lift away from the plate, revealing the image in bare metal. If, then,
the usual aquatint procedure is followed, the image will be bitten into
the plate.

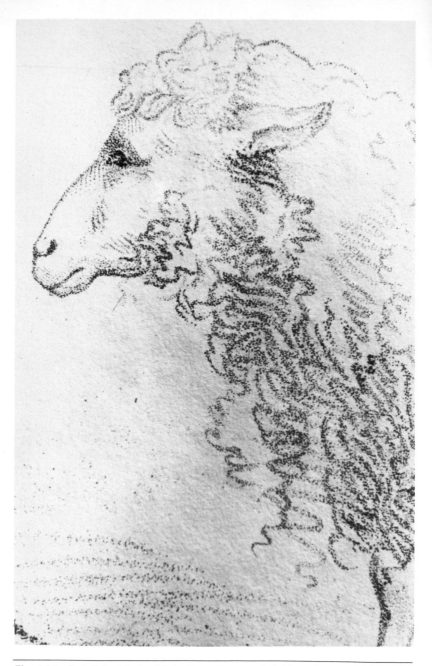

Fig. 1.11 Detail (c. 3 in by 2 in) of a soft-ground etching, date and engraver unknown

Fig. 1.12 Detail (c. 3 in by 2 in) of a stipple engraving by Francis Holl.
Published 1860 (Ross Collection)

Stipple engraving

A stipple engraving (Fig. 1.12) is produced by piercing the wax
ground on a plate with a series of pecks, using an etching-point or
other suitable tool. In former times, this was often done in imitation
of the granular effect of crayon. Each peck reveals a dot of bare
metal which is subsequently attacked by acid to create a small pit.
Chemical and mechanical principles are often combined in the stipple
technique: for particularly delicate effects the ungrounded metal is
stippled with an engraving tool rather than etched. Stipple engraving

Fig. 1.13 Detail of a drypoint

became popular in England largely through the work of the
Florentine expatriate Francesco Bartolozzi (1727–1825) and his
followers.

Drypoint

Drypoint (Fig. 1.13) is a method of producing an intaglio print by
simply scoring the metal plate with a steel point, pulled across the
surface towards the engraver. The tool displaces (rather than
removes) the metal, raising a ridge alongside each furrow. The ridge
(called a burr) retains ink when the plate is wiped after inking, and
prints a characteristically soft, velvety line. Due to the friction of the
inking and wiping process and to the pressure of printing, the burr
of a drypoint begins to flatten after very few impressions.

Mezzotint

In mezzotint (Fig. 1.14), the surface of the plate is evenly and
systematically roughened all over with a rocker (a tool like a chisel
with a short, broad blade whose cutting edge is curved and serrated;

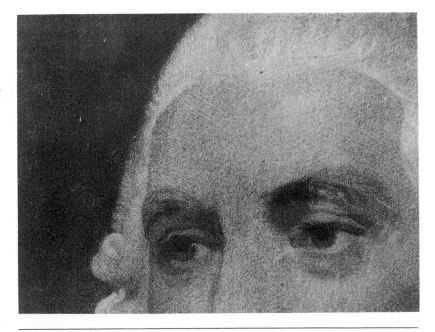

Fig. 1.14 Detail (c. 2 in by 2½ in) of 'Rt. Hon. Henry Dundas of Melville',
mezzotint (13 in by 10⅞ in) by John Raphael Smith, after the portrait by Sir
Joshua Reynolds. Published 1783

see Fig. 2.4). The dense texture raised by the rocker would, if inked, hold so much of the pigment that it would print solid black. The engraver achieves the full range of tones required in the final print by proceeding from this black to the lighter tones, smoothing the surface of the plate to varying degrees with implements known as scrapers and burnishers. The areas left roughest retain most ink and thus print blackest; those polished smoothest retain little or no ink and therefore provide the highlights.

You will quickly learn to recognise these various processes once you understand the principles on which they are based. Of course, your understanding will be all the surer if you actually produce intaglio prints yourself. Once you have bitten or engraved a plate and run it through a press to produce a print, you are never again likely to be fooled by the careless reference to a pen-drawing as 'an etching'. And the use of a magnifying glass will help you to recognise interesting combinations of processes in a single print. Although these processes have here been described separately for convenience, and although they often are (and have been) used 'pure', they are just as frequently mixed.

The workshop, materials, tools and equipment

The two main processes entailed in making intaglio prints are of course the preparation of the plate and the printing, and the workshop needs to be organised accordingly. A wide range of substances, solvents and pigments is necessary in intaglio printing and, since the hoped-for outcome is a set of sparkling prints with spotless margins, workshops large or small need to be highly-disciplined places (Fig. 2.1)

WORKING SPACE

The essentials are: as much uninterrupted working surface as possible (one large surface being far preferable to several scattered ones); enough floor space to enable the press to be operated conveniently (some presses demand more space than others, as we shall see); adequate storage space for paper, plates, inks and chemicals; and good ventilation. Working procedures will have to be adjusted according to the size of room available. While in a large room, separate areas can be allocated to the preparation of plates and to inking and printing, the same surface in a smaller room may have to be used for all these stages in printmaking. In this case, the discipline must be even stricter: the work surfaces will need to be carefully cleared after each stage in preparation for the next, if chaos is to be avoided. But again, much depends on the individual artist or craftsman. Georges Braque's studio was always highly organised, with drawing and painting implements carefully set out in rows on strips of corrugated card; Alberto Giacometti, on the other hand, seemed able to work in a disordered, paint-spattered environment. Some printmakers need space; others can manage in the most cramped conditions. For instance, Lawrence Josset the mezzotint engraver (shown at work in Fig. 4.15) finds that a small table in his living room is adequate for most of his work on plates.

Of course, there must be some relationship between the scale of work you hope to produce and the space in which you work. Large

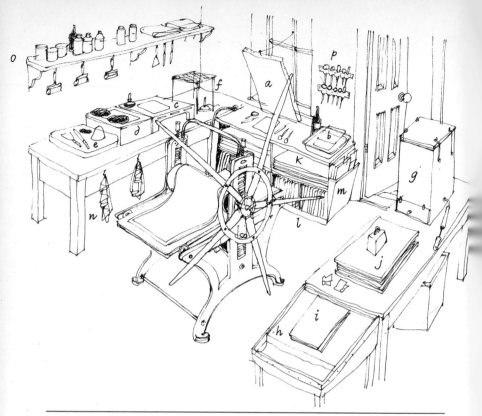

Fig. 2.1 A workshop and its equipment: (a) light diffuser; (b) acid bath; (c) gas hotplate; (d) gigger; (e) inking slab; (f) Bunsen burner and grille; (g) aquatint box; (h) wetting trough; (i) wet paper draining; (j) damp paper under weight, ready for printing; (k) paper shelves; (l) plate racks; (m) scrap card; (n) scrim (muslin) for wiping plates; (o) shelf for inks, rollers etc.; (p) tool rack made from strips of webbing

plates demand a large press and also correspondingly generous areas of working surface. I have a press which will take plates up to 22 in by 15 in, though most of my plates are about half this size, or less. I find that a working surface of about 30 ft^2 meets most of my needs.

Plates and presses will be discussed in detail in subsequent chapters, as will the ways of using various tools and materials. This chapter will simply consist of a kind of inventory of the essential materials, tools and equipment for making intaglio prints.

Acids

Etchers have used very many recipes for mordants, or acids, but nitric and hydrochloric acid will be sufficient for working on zinc or copper, the metals most commonly used. Nitric is simplest to use,

since it only needs to be added to an appropriate volume of water. Hydrochloric acid, added to potassium chlorate and water, produces what is known as Dutch mordant. Any reader wishing to find out more about acids should consult E. S. Lumsden's *The Art of Etching*, full details of which are given in the bibliography. The author discusses all aspects of the craft in very great depth, and most serious students will eventually wish to seek the kind of guidance he and others can give. But for our present purposes, since it is difficult enough to master the use of even one acid, let us restrict ourselves to the nitric solution and to Dutch mordant. The stronger the acid solution, the more quickly it will bite. Some etchers mix an equal volume of nitric and water. This solution, or one a little weaker, say, one part acid to two parts water, will be suitable for copper. Since zinc is a softer metal, one part acid to ten parts water will be adequate for use with that metal. For use with copper, Dutch mordant (which, though slower to act, bites more accurately than nitric; the latter attacks slightly raggedly) may be mixed as follows: 20 parts of hydrochloric acid, 3 parts of potassium chlorate, and 77 parts of water. For use with zinc, the proportions are 10, 2 and 88 respectively. Whether on copper or on zinc, a weaker solution is needed for aquatint than for the etching of line work. Individuals will need to experiment for themselves. It is impossible to say how long a plate should be left in a given acid solution; it depends on the depth of bite required. The matter is further complicated by the fact that acid bites more vigorously in a warm atmosphere than in cold weather. The best way to become initially acquainted with acid and its ways is to make an experimental plate like that shown in Fig. 4.4. This has been done rather like a photographic test strip. After a short time in the acid the plate was removed, rinsed, dried, and a narrow strip painted with protective quick-drying varnish. Then the plate was returned to the acid and subsequently another area protected, and so on.

RESISTS

The basic acid-resistant materials are wax (hard and soft, Fig. 2.2), a varnish known as straw-hat varnish, and powdered resin. The characteristics of hard and soft wax have already been mentioned (p. 12, above). The usual function of straw-hat varnish is to 'stop out' during the etching process those parts of a plate where biting is judged to have gone far enough. It is also used to protect the reverse side of a plate and its edges. The fluid is black, so it can easily be seen when used for intricate passages of stopping-out; it is extremely quick-drying, so that interruption to the work is minimal. Asphaltum dissolved in white spirit will do a similar job, as will shellac crystals

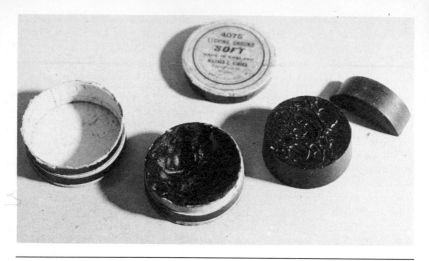

Fig. 2.2 Cakes of hard and soft wax, or etching ground. These are about 1½ in diameter

dissolved in methylated sprits. The first, though, is not quite so quick-drying; the second not so clearly visible – certainly not on copper.

CLEANERS AND SOLVENTS

Ammonia, whiting and Brasso (used with cotton wool to reduce the risk of scratching) are needed for cleaning plates; and white spirit and methylated spirits are the basic solvents. White spirit will dissolve wax, ink and asphaltum; methylated spirit is used for straw-hat varnish, shellac and resin.

TOOLS

Many of the tools (Figs. 2.3, 2.4) for work on plates can be improvised. The tool kits of most craftsmen will contain items adapted or specially made to suit the individual user. An etching point can be any pointed implement: even a filed nail mounted in a convenient handle, or a cocktail stick mounted in a cork, would do. Anything which will travel smoothly through the layer of wax and cleanly reveal the metal of the plate beneath will serve perfectly well. Some tools, though, are more difficult to improvise: scrapers, burnishers and rockers (Fig. 2.5) for use in the mezzotint process

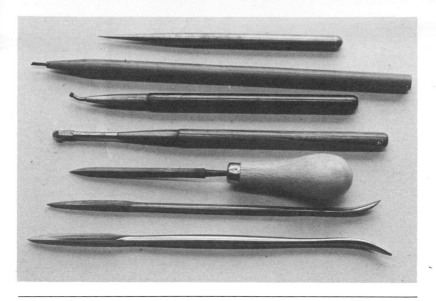

Fig. 2.3 Etching and engraving tools. The implement at the top is a drypoint; the bottom three are scrapers, two of them equipped with burnishers

have to be professionally made, and the tools for drypoint need to be extremely hard if they are to plough efficiently through the metal. Toothed roulettes (see Fig. 2.4) are useful for producing dotted effects, and files for bevelling the edges of plates are indispensable. A leathercovered roller (Fig. 2.6) or, alternatively, a mushroom-shaped dabber (Fig. 2.10) for applying wax grounds completes the list of essential tools for the preparation of plates.

EQUIPMENT

Much of the equipment needed for work on plates can be improvised, too. While a ceramic or plastic acid tray is convenient, etchers at one time used to build a low wall of wax around the edges of a prepared plate and pour the acid into the 'tray' thus formed; and during the seventeenth-century, it was common to bite plates by resting them on pegs in a sloping board and pouring acid over them from a jug. The acid, collected in a trough beneath the board, was poured repeatedly until the plate was deeply enough bitten. It is usual for workshops nowadays to be equipped with gas or electric hotplates (see Fig. 2.1). As well as for use in inking (page 84, below), these are for warming the zinc or copper plate so that the cake of wax will melt on contact, ready for spreading with the roller or the dabber. T. H. Fielding has described a heating device used in

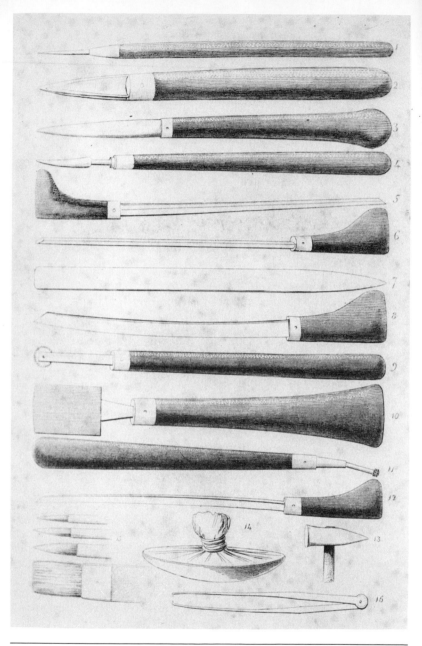

Fig. 2.4 Engraver's tools, Fielding, 1841 (St Bride Printing Library, London)

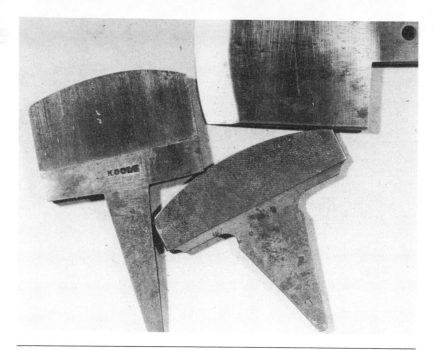

Fig. 2.5 Mezzotint rocking tools. The two below are face-up, the ridged surfaces visible. The one above is face-down, showing the bevelled edge which is sharpened on an oil stone

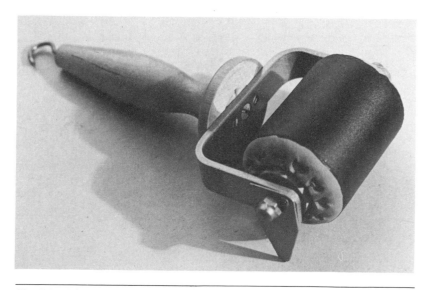

Fig. 2.6 A leather-covered roller for applying wax grounds

the nineteenth-century: a shallow tin box, filled with boiling water through a hole in one corner, resting on a stand and kept hot by means of a small spirit stove beneath. It was observed above (p. 12) that resin powder may be sprinkled on to a plate by hand (see Fig. 4.9) or in a specially constructed box. Such a box can easily be made from wood, and the resin agitated inside it by means of a flapper device rotated with a cranked handle or, more simply, with a bicycle pump (see Fig. 2.7). The reflections from a shiny metal plate can be rather troublesome, and it is much easier to see what one is doing if a light diffuser – tissue paper or tracing paper pinned to a light wooden frame – is placed between a window and the working surface. While a Bunsen burner (see Fig. 2.1) or something like a primus stove is useful for melting aquatint grounds, a plate sprinkled with resin can always be carried on a grid and heated over the jet of a domestic gas cooker. For that matter, wax grounds can also be laid by this means.

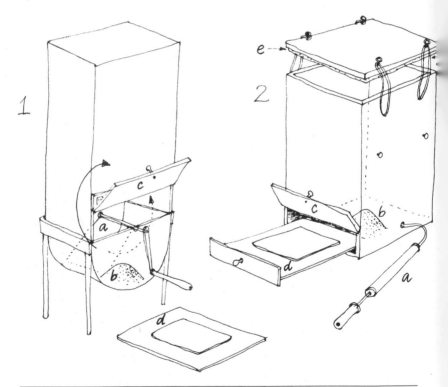

Fig. 2.7 Aquatint boxes. In (1), the flap (c) is closed and the 'paddle' (a) is operated by the cranked handle so that the pile of resin powder (b) flies like a snowstorm inside the box. Then, the flap is opened and the plate is slid in on a tray (d). The flying resin settles on it in an even layer. In (2), the resin is agitated by the bicycle pump. The lid is held down by strong elastic bands (f) and the lining of draught excluder (e) makes a secure seal

Now to turn to the printing process. The ink (Fig. 2.8), usually referred to as etching ink or copper-plate ink, is obtainable in black and a wide range of colours, though in this book we shall have little to say about coloured inks. Copper-plate ink is a dense pigment ground in boiled linseed oil. It is supplied ready for use, or the powder and the oil can be bought separately. In the past, the best blacks came from France and from Germany: French black was made from the lees of wine, and Frankfort, as the German variety was known, was made from charred animal bones. Genuine French and Frankfort are no longer obtainable, but there are many commercially-produced substitutes. Ready-mixed ink in tins is convenient, though its consistency may have to be modified by the addition of a little linseed oil. Also, however carefully the tin is sealed again after use, the ink quite quickly forms a thick crust. Many printmakers find it preferable to mix batches of ink as they need it; and this process will be described in Chapter 7.

Other requirements for the inking process are muslin and whiting. Two types of muslin are necessary: stiff and soft. The stiff muslin has quite an open weave and is impregnated with glue size. It is sometimes called scrim, and in the nineteenth-century was referred

Fig. 2.8 A tin of Charbonnel intaglio printing ink

to as 'wiping canvas'. Its stiffness and openness make it ideal for the first phase of wiping. The softer muslin is for use after most of the ink has been removed. The whiting may be in powder or in block form; its use in the final stages of wiping ink from the plate will be explained later (page 85).

Acid-free tissue paper and white blotting paper are useful for interleaving damp prints, and some sheets of $\frac{1}{2}$ in insulation board or chipboard and some iron weights will do for flattening them.

When mixing powder pigment with linseed oil, a muller (see Fig. 2.9) is needed. This is a roughly hemispherical lump of hard stone which can be held in both hands, the flat surface grinding the powder into the oil against the ink slab. Palette knives and flat scrapers are also useful for initial mixing and, of course, for cleaning up afterwards.

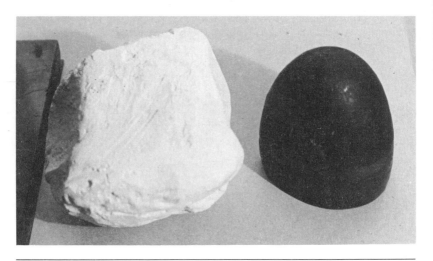

Fig. 2.9 A block of whiting and, right, a muller

The traditional implement for applying ink to the plate is a dabber (Fig. 2.10), similar to that used for waxing but covered with a layer of the fine woollen felt used as a press blanket (see p. 1, above). However, a hard rubber roller with a piece of the same material stitched carefully round its cylinder is even better (Fig. 2.11). Other requirements are what the French call *poucettes* – pieces of strong paper folded with the aid of a pencil (Fig. 2.12) or very thin metal with which the printer handles paper to keep it free of inky fingerprints – and a very soft brush (a baby's hairbrush is ideal) for removing excess moisture from the surface of sheets of paper just prior to printing.

The bench or table on which inking takes place should be long enough to carry a slab for mixing ink, a heater of some kind and a

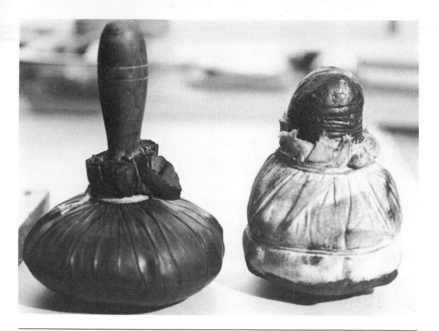

Fig. 2.10 Dabbers for applying ink and/or wax. The one on the left is commercially produced; that on the right has been made in the workshop

Fig. 2.11 An inking roller. The cylinder has a piece of press blanket stitched round it, to help deposit ink more effectively in the crevices of the plate

Fig. 2.12 Poucettes, or grippers, of strong paper

wooden box (called a gigger) to support the plate while it is being inked and wiped. There should also be room for the block of whiting or for a shallow dish containing powdered whiting. The muslin can be hung on a rail beneath the working surface or on a string stretched above it. The heater or hotplate will be the same as that used for warming plates to be waxed. Ink can be worked more easily into the crevices of a warmed plate, though it is not so necessary nowadays to warm the plate during inking as it was forty or fifty years ago; then, the oils that formed the basis of intaglio printing inks were boiled to a rather heavier consistency than they are today. However, a little warmth still helps; and, certainly, if a plate is warmed just before it is put in the press, the ink will transfer more readily to the paper. It will be handy if the gigger is exactly the same height as the heating device, so that the warmed plate can conveniently be slid from surface to surface. It is interesting to compare the layout of the nineteenth-century French plateprinter's bench (Fig. 2.13) with that of a printer working today. The only real difference is that the former warmed his plates with a charcoal heater (shown at 9 in the diagram), whilst the latter uses a gas (or electric) hot-plate.

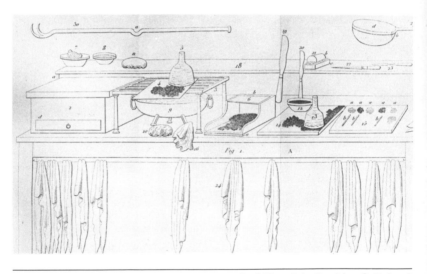

Fig. 2.13 A plateprinter's work bench. Detail of Plate 2 in Berthiau & Boitard, 1836 (St Bride Printing Library, London)

PREPARING THE PAPER

The printing paper needs to be damped; this makes the fibres supple and enables the paper to be pressed into the very deepest crevices of

the plate during the passage through the press. A trough of water with a sloping surface adjacent to it provides a convenient means of wetting paper. The wet sheets can be stacked on the sloping surface so that surplus water drains back into the trough (see Fig. 5.1). However, all that is really necessary is a couple of sheets of plate glass (or flat, heavy zinc) between which sheets of paper soaked with a sponge can be sandwiched until they have reached the necessary degree of suppleness.

The plate

THE INTAGLIO PRINCIPLE

Intaglio printing has been described as a form of sculpture, and this is quite a helpful, illuminating description. The intaglio principle can easily be understood by making what is called a 'blind' print from any kind of textured surface, found or made. Such a surface needs, of course, to be flat enough to pass between the rollers of a press. For example, the printed circuits used in electronics provide interesting surfaces; but perhaps the simplest way to grasp the principle is to make cuts in a piece of linoleum and, using damp, supple paper, to make an un-inked ('blind') impression from the block. The 'blind' print shown in Fig. 3.1 was made in this way. Hardboard or plywood would do just as well: Fig. 3.2 and 3.3 show

Fig. 3.1 Detail of a blind (i.e. un-inked) intaglio print made by taking linoleum blocks through a rolling-press with damped paper (students' work, University of London Institute of Education)

Fig. 3.2 (left) Detail of a blind intaglio print made from engraved hardboard (student's work, University of London Institute of Education)

Fig. 3.3 (right) Detail of a print made from the hardboard 'plate' shown in Fig. 3.5. This time, the flat surface of the hardboard has been inked, so that the print is strictly a relief print, though embossed like its companion

two prints made from the same piece of engraved plywood; Fig. 3.2 shows an un-inked intaglio print, the damp paper having been forced into the crevices to produce a print resembling a sculpture in low relief. Figure 3.3 shows, by contrast, a surface print, i.e. a print made from a plate or block with ink deposited *on the surface* rather than worked into the crevices. If you were to work ink into the crevices of a lino block and then wipe the surface clean (and, with care, this can be done) you would produce from it an intaglio print. In the same way, although the sculptural effect may be less immediately evident, etchings and engravings made from metal plates have this relief quality.

COPPER PLATES

Until early in the nineteenth century, the metal most commonly used by etchers and engravers was copper, which is relatively easy to engrave, and various acids will etch it efficiently. With patience,

errors can be corrected by scraping away unwanted passages. If this scraping has to be done to any considerable depth, the hollow thus created in the plate's surface will need to be 'knocked up' from behind so as to make it level again, resting the plate face down on an anvil. The point on the back of the plate where the 'knocking up', or hammering (with a round-headed hammer), needs to be done can be calculated with the aid of calipers. Burnished and polished, the treated area of the plate's surface is ready for re-working. Although it can be worked with relative ease, copper is durable enough to yield quite a large number of impressions without significant deterioration. The wiping process and, to some extent, the passage between the rollers of the press, will in time affect the surface of any intaglio plate; prints will be less and less crisp and brilliant the more worn the plate becomes. This is hardly a problem when small editions of prints – say, up to fifty or a hundred – are to be made; but it certainly *was* a problem when plates were used for book illustration, for map printing or for banknote printing, and perhaps hundreds of thousands of impressions were required.

STEEL PLATES

Plateprinting was an enormous industry in Britain by the beginning of the nineteenth century. Trade cards, labels, bill-heads, tickets and all manner of ephemera as well, of course, as pictures, were produced by the intaglio process. The spread of the Industrial Revolution and the rapid growth of the population brought an increased demand for commercial printing, for illustrated books and journals and for prints to be enjoyed simply as decoration. Longer printing runs were thus necessary, and engravers and platemakers began to try and devise steel plates that could be softened so as to make etching and engraving on them feasible, but which could afterwards be hardened so that they were capable of almost unlimited printing runs. Many platemakers lived and worked in and around Shoe Lane, off Fleet Street, in London; their names and addresses can still be found stamped into the backs of old copper plates. Some of the plates of the Spanish artist Goya (1746–1828) bear the name of a platemaker named Pontifex, who lived in this area. It seems to have been Richard Hughes, another member of this community of tradesmen, who, in collaboration with an engraver named Charles Warren, produced the first successful steel plate by about 1820. This revolutionised the engraving and printing trades, and for the next thirty years or so, until overtaken by lithography and eventually by wood engraving, steel engraving became the commonest form of book illustration. However, in spite of the softening process, the metal was

still very hard to work in; and you can sense this hardness if you examine the detail of a steel engraving. The print seems to have a diamond-hard quality about it, a certain coldness – though frequently quite beautiful in its own way – that contrasts with the rather softer, warmer quality of a print made from copper.

STEEL-FACING

Another solution to this problem of plate wear seems to have been devised by two Frenchmen, Salmon and Garnier, in the mid-1850s. They discovered a way of depositing a thin layer of iron on previously engraved copper plates. The process used is known as electrolysis – a process akin to that used in chromium-plating today. The advantage of this method over the use of solid steel plates was that an etching or engraving could be made in the much more sympathetic metal, copper, which would then, with its protective layer of iron, give very many more prints. The amazing thing is that this process (loosely called 'steel-facing') does not, if properly carried out, obscure even the finest crevices in a copper plate. The secret seems to have been pretty closely guarded, since steel-facing did not come into general use on this side of the Channel until late in the nineteenth century. Many etchers and engravers still take their copper plates to the one or two surviving steel-facing plants for the protective coating that will make their work virtually indestructible – provided, of course, that they are kept greased or varnished when not in use, to keep rust at bay.

PLATE WEAR

The life expectancy of an unprotected copper plate will be determined not only by the extent to which it is printed, but also by the particular process used. To put it in a nutshell: a plate which has been etched or engraved by *removing* metal will be more durable than one in which the metal has been displaced. It was explained on p. 17, you will remember, that processes such as drypoint and mezzotint displace metal rather than remove it; the drypoint tool and the mezzotint rocker cause metal to be raised *above* the surface even as they plough or bite *below* it. With repeated printing, these raised ridges and crowns will gradually flatten, and only steel-facing will significantly prolong the life of drypoint or mezzotint plates. Some of the most splendid mezzotints in the history of the art were printed from unprotected copper. John Raphael Smith (1752–1812), working

before the invention of either the steel plate or of steel-facing, was one of a small group of engravers who reproduced the portraits of Sir Joshua Reynolds (1723–92) in mezzotint. A detail of his work is shown in Fig. 1.14). Still, there is a dramatic difference in quality between prints taken from any mezzotint (or drypoint) plate early in its life and one taken after it has been affected by some wear. This explains why the first few in any printing run were – and are – in great demand by connoisseurs. The typical edition of a nineteenth-century reproductive engraving, for example, included what were called Artist's Proofs, Presentation Proofs, Proofs Before Letters (i.e. before the title of the picture was engraved at the foot of the plate), and Lettered Proofs, all in limited numbers. Thus, anyone buying an Artist's Proof would know that the print had been made early in the life of the plate, while all the detail was still sharp and clear. In addition to the above categories, impressions with no numerical restriction were made. Because unrestricted, and because made at a stage when the plate had begun to lose its pristine clarity, such impressions were sold considerably cheaper than the earlier ones. For example, Artist's Proofs of Edwin Landseer's 'Monarch of the Glen' (published in the 1850s) were sold at 10 guineas, Proofs Before Letters at 8 guineas, Lettered Proofs at 5 guineas, and plain prints at only 3 guineas.

'MIXED' METHODS

Because of the relatively short life of a pure mezzotint plate, a method known as 'mixed mezzotint' was evolved by mid-nineteenth-century engravers. This method entailed a great deal of etched and engraved work – that is, *removal* of the metal – as well as the use of the mezzotint rocker. The print shown in Fig. 1.1 was produced by this mixed method. Tools such as roulettes (devices with toothed wheels) were used to make textures that could be bitten through a wax ground laid on a plate, and lavish use was made of ruling machines (Fig. 3.4). These were first used in England about 1790, and seem to have been the invention of an engraver named Wilson Lowry (1762–1824). By the 1840s these machines, usually operated by specialists to whose workshops engravers would take their plates, had become highly sophisticated and efficient, and were capable of ruling not only finely-spaced parallel lines, but undulations and complex patterns of all kinds (Fig. 3.5). In pictorial plates, they were used mainly for skies. If you look closely (perhaps you will need a magnifying glass) at the sky of a mid-nineteenth-century engraving you are almost sure to see that it is composed of closely-spaced parallel lines, bitten to varying depths to achieve the effect of clouds.

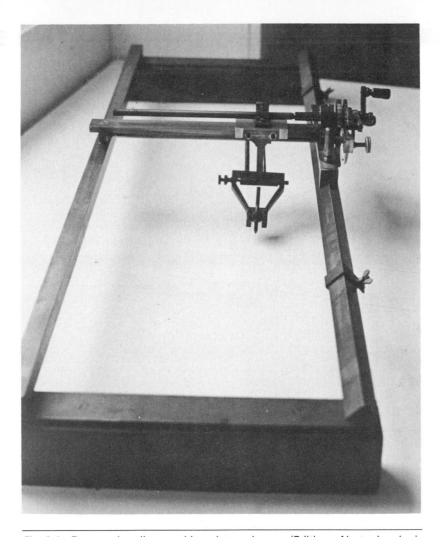

Fig. 3.4 Engraver's ruling machine, date unknown (Editions Alecto, London). The needle travels across a grounded plate, the whole mechanism sliding backwards and forwards along the diamond-section bar

ZINC PLATES

It is important for all students of etching or engraving to understand these details of their craft; but while some may wish to experiment with these methods and may ultimately wish to have their plates steel-faced, most will be content to work on and print from bare copper. At least, they would be content to do so if they could afford it; but copper is now so expensive that zinc may have to be used as a

Fig. 3.5 Detail (c. 3 in by 2 in) of an architectural engraving (15 in by 8½ in) made with aid of a ruling machine by J. Roffe after a drawing by John P. Gandy nineteenth century

substitute. Zinc is considerably cheaper than copper; it is also considerably softer and somewhat coarser in structure. However, the surface does take quite a good polish, and an etched or engraved zinc plate will give at least twenty-five good impressions. One would be lucky to get more than three or four really good prints from a drypoint or mezzotint in zinc; and unfortunately, a zinc plate cannot be steel-faced – at least, not without the intervening process of copper flashing.

PREPARING THE PLATE

Whether of copper or zinc, a plate needs to be smooth and polished. The only really practicable thing to do is to buy the metal ready cut to size and ready polished. If it is to receive a wax ground, it will also need to be carefully cleaned; however sparkling it may look, there will almost certainly be an imperceptible film of grease to be removed if the layer of wax is to adhere properly. The cleaning is best done by pouring a few drops of ammonia on to the surface, sprinkling into this some powdered whiting, and working the

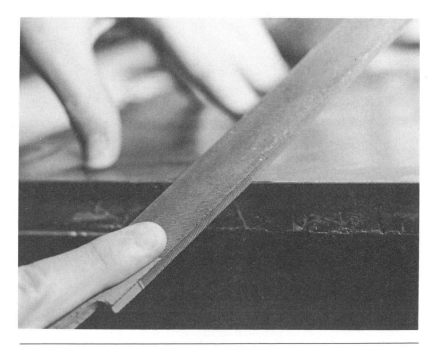

Fig. 3.6 Bevelling the edges of a plate

resultant paste all over the plate with a pad of absorbent rag until it disappears. Also, the edges of the plate will need to be filed (Fig. 3.6) so that they are gently bevelled and will thus not cut through either paper of press blankets during printing. The bevelling may be done before any work is done on the plate; or it can be delayed until just before the first proof is to be taken.

Most plates manufactured for intaglio printing are 18-gauge. Roofing zinc is, however, sold in much thinner sheets. This thinner metal can easily be cut to size with tin-snips, and plates made from it are an inexpensive substitute for the heavier gauges.

Etching and engraving techniques

Although, as we have seen, many different techniques may be used on a single plate – and frequently are, to excellent effect – it will obviously be clearer if in this chapter each is described quite separately.

LAYING THE WAX GROUND

Laying a wax ground can be tricky. It is essential to clean the plate, as described in the previous chapter, and then to heat it to the extent that a cake of wax will readily melt when rubbed on the surface. There are many recipes for making wax, and there was a time when etchers and engravers always concocted their own, but both hard and soft wax can nowadays be bought ready for use (Fig. 2.2). There exist leather-covered rollers (Fig. 2.6) for spreading the melted wax thinly and evenly on the plate. This rolling needs to be done with a deft, light stroke, and it is all too easy for the roller to slither out of control if the plate is too hot, or to pile up the wax too thickly if it is too cool. It is perhaps surer, though slower, to lay the ground with a dabber (Fig. 2.10). Dabbers can be bought, though they are easy enough to make: it is simply a matter of covering a disc of cardboard, about 2 in diameter, with suitable padding – cotton wool will do – and tying the whole thing up in a piece of soft leather such as chamois or kid to form a mushroom shape. The edges of the leather can be held in the fingers of one hand and whipped securely with string, working from the fingers towards the disc, so as to tighten the leather. Fine silk also makes a suitable covering for a wax dabber. With the aid of this implement, the wax can be spread evenly over the plate, using a slightly rocking, tapping action, and taking care to make the layer so thin that the etching point will travel freely through it. The wax ground should be so thin that the metal will still reflect through it, though there should obviously be no speck of bare metal visible. The cake of wax is dark brown; when laid as a ground, its colour should be quite golden.

As the plate cools, the wax ground will become dull and, within a few minutes, it will be hard enough to handle. At this stage, many etchers blacken the ground with smoke from tapers. This will make more visible the metal laid bare during needling; but it is not really necessary – certainly not in the case of a white metal such as zinc.

ESTABLISHING THE IMAGE

Different individuals will work with different degrees of deliberation. Some will attack the grounded plate directly with the etching point, drawing quite freely through the thin ground; others may wish to trace the outlines of an image on to the plate before proceeding. The tracing method used by nineteenth-century reproductive engravers was as follows. The engraver would make a careful pencil copy (reduced in scale, if appropriate) on thin paper of the picture he was preparing to reproduce. The copy would be laid, drawn side down, on the surface of a grounded plate, and then plate and paper would be taken through a press under light pressure, whereupon the drawing would be transferred in silvery lines on to the wax ground as a guide for the subsequent needling. For tracing purposes, the ground would be best blackened, as described above.

VARNISHING THE PLATE

The back and the edges of the plate need to be protected before it is immersed in the acid. Black straw-hat varnish (Fig. 4.1) is extremely convenient for this purpose, since it dries to the touch in a matter of minutes. Used with a fine brush, it is also ideal for stopping out any unwanted lines or scratches in the wax before the acid gets to work. The needling, by the way, should have been done with such lightness of touch that the metal beneath has not been obtrusively scored; so, no harm is done if a few surplus lines are cancelled out with varnish at this stage.

BITING THE PLATE

A solution of one part of nitric acid to ten parts of water is relatively mild; but even such a solution, if not used with great care, can be dangerous. You can safely lower plates into the solution and remove them from it with the fingers, as long as the hands are immediately afterwards rinsed in water. A surer method is to lower the plate into the

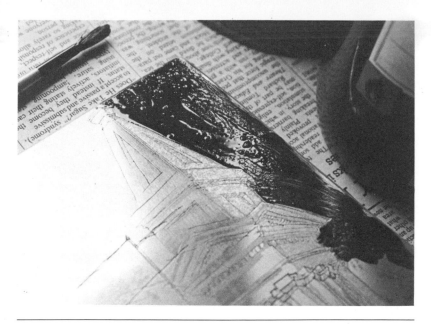

Fig. 4.1 Protecting a plate with straw-hat varnish

bath with a length of string passed under it, towards one edge
(Fig. 4.2). The string can stay under the plate during biting, its ends
over the sides of the bath, ready for the retrieval. The immersion and
removal of plates must be done calmly and carefully; a plate dropped
clumsily into the acid can cause splashes which, if not rinsed away at
once, can damage clothing or, much worse can enter the eye. As
always, prevention is better than cure, and it is advisable to wear
laboratory spectacles while handling acid; but if a splash does get into
the eye, it should be rinsed copiously with water and hospital treatment
should be sought at once. The most hazardous operation is, of course,
mixing the solution prior to use. The undiluted acid should be kept in a
securely-stoppered glass bottle, and should be very gently poured into
the water. This should *never* be done the other way round: adding water
to acid can produce a dangerous reaction. Separate bottles, clearly
labelled, can be used for the diluted fluid. Although it may seem
tiresome, it is a good idea to pour the solution back into a bottle with
the aid of a funnel immediately after use. Otherwise, fumes will get into
the atmosphere of the workshop, and objects of ferrous metal will quite
quickly begin to corrode; nor are such fumes good for the lungs!
Strictly speaking, the acid bath should be enclosed in a booth equipped
with a fume extractor, and time spent bending over it to inspect the
progress of a plate's biting should be minimal. At the very least, acid
should be used in a well-ventilated room, near an open window, or in
an airy shed or a convenient open space.

Fig. 4.2 Lowering a plate into the acid bath

Fig. 4.3 A linen-prover

When a plate is lowered into the $1 + 10$ solution of nitric acid, bubbles will begin to form like strings of tiny pearls along the lines of bare metal. These should be brushed away from time to time with

a feather so that the acid can continue its work unimpeded. When it has been immersed for, say, ten minutes, the plate can be lifted out. It should be rinsed and the surface gently dried with blotting paper. The depth of the bite can then be gauged by careful probing with a needle, or it can be checked visually with the aid of the powerful magnifier known as a linen-prover (Fig. 4.3). Then the real work begins.

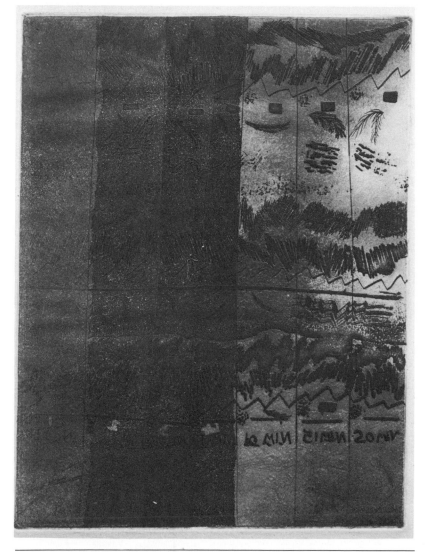

Fig. 4.4 A print from an experimental plate (student's work, University of London Institute of Education)

Fig. 4.5(a), (b) and (c) Working proofs of three stages in the evolution of an etched and aquatinted plate, Joseph Dyson (age 13), 1981

STOPPING OUT

As we saw in the introduction, the lines and textures of an etching
are given varied weight through a system of successive immersions in
acid. After the first light etch, all those areas of the plate where
biting is judged to have gone far enough will need to be stopped out
with straw-hat varnish. For example, if the subject is a landscape,
many of the distant features could be stopped out at this stage so
that, when contrasted with a more deeply bitten foreground, they will
appear to recede. Then the plate may be replaced in the acid for a
further period, after which the next phase of stopping out takes
place. This can be repeated any number of times, the most deeply-
bitten passages being the result of a total period of immersion of an
hour or more. Figure 4.4 shows a print made from a test plate on
which this principle has been explored in line and in aquatint. Figure
4.5 shows a print in various stages, or states. In Fig. 4.5(a) the print
shows that the plate has already undergone several bites: the most
delicate lines (for instance, of the paving stones in the foreground)
are the result of a five-minute bite; the heaviest (for instance, the line
of the arch and column running down the right hand edge) are
produced by a bite of up to an hour. It can be seen in Fig. 4.5(b)
that the aquatint texture in the water and sky is the result of two
immersions in the acid. After a couple of minutes in the bath the
plate was lifted out, rinsed and blotted dry. Then, areas of varnish
were applied, to indicate clouds and ripples, and the plate was bitten
for a further minute or two – hence the two tones. In the final print
(Fig. 4.5(c)), the range of tones on the buildings has been produced
by laying a new aquatint ground (as described on p. 49, below) and
biting in several stages. It is possible for this whole process to be
conducted backwards, as it were. Some etchers like to needle what
are eventually to be the most deeply bitten lines, lower the plate into
the acid and then, while the plate is immersed, continue the
needling. With this procedure, the lines drawn *last* will be most
lightly bitten. A stipple engraving is produced in exactly the same
way as an etching, the tiny dots of metal protected or left bare
according to whether they are to print light or heavy.

SOFT-GROUND ETCHING

A soft wax ground is laid in the same way as one of hard wax. If flat
objects – feathers or fragments of textile fabric, for instance – are
placed on a plate prepared in this way and covered with a piece of

greaseproof paper, the whole can be taken under light pressure through a press and, when the objects are lifted, they will bring the wax with them, leaving their shape perfectly revealed in bare metal. The greaseproof paper prevents the soft wax from transferring to the blankets of the press. Thomas Gainsborough (1727–88) had begun to experiment with soft-ground etching as early as the 1770s, and some of his plates worked by this method are displayed in the Tate Gallery, London. His method was to lay a sheet of thin paper (one with a slight texture being most effective) on the soft wax and make a pencil drawing on it so as to lift the wax beneath. Such a drawing is reproduced with astounding accuracy through the wax ground (Figs 4.6 and 4.7). It is a good idea to fix the paper firmly to the working surface all round the plate, to keep it from moving while the image is being established. It is also advisable to make a wooden handrest to span the plate like a shallow bridge. The biting of a soft-ground plate is done in the way described above (page 45), parts of the image protected with varnish from time to time according to the etcher's intentions.

Fig. 4.6 Pencil drawing made to produce the soft-ground etching in Fig. 4.7

Fig. 4.7 Soft-ground etching with letterpress, Lawrence Josset

In his manual of 1841, T. H. Fielding quoted a contemporary as claiming that aquatint was an art 'invented for the torment of man'. Another nineteenth-century writer, C. F. Partington, warned that 'no printed directions whatever can enable a person to practice it perfectly'. This is, of course, true of all practical matters: the only really effective teacher is experience. It is true, though, that aquatint – a technique used by English engravers from about 1775 – can be particularly frustrating. Powdered resin is most commonly used for applying aquatint grounds, and can be sprinkled on to a plate by hand or in an aquatint box. A small tin covered with several layers of muslin makes a perfectly serviceable filter for hand sprinkling. If the resin dust is to drift with any predictability on to the surface of the plate (which, just as for a wax ground should have been cleaned with ammonia and whiting), this operation must be carried out in a draught-free atmosphere. The resin should be sprinkled exactly as if dusting icing-sugar on to a cake (Fig. 4.8). The plate needs to be supported on a surface slightly larger in area than itself – a piece of strong cardboard will do – resting on a small box. The falling dust has a way of curling away from the edges of a plate, leaving them more thinly sprinkled than the centre. The piece of cardboard will help to correct this, and the small box makes it possible to lift the plate, fingers underneath, without disturbing the resin (Fig. 4.9). The usual fault is to sprinkle too thinly. A fair idea of just how dense the ground is can be gained by looking at the plate's surface from an angle that allows light to be reflected from it. The specks of resin will show dark against the shining metal, and will at once be seen to be far more thinly scattered than when they appear pale against darker, unreflecting metal. The resin should not be sprinkled too thickly, either. Ideally, there should be a single layer of grains, each surrounded by bare metal.

The covered plate can be carried on a metal grid to a source of

Fig. 4.8 *Resin sprinkled on a plate, ready for melting*

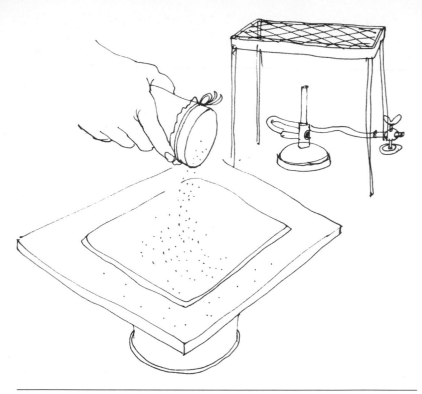

Fig. 4.9 Sprinkling resin powder by hand

heat, or it can be placed on a device such as that shown in Fig. 4.9, positioned over a Bunsen burner. As soon as the resin on any part of the plate begins to lose its paleness and become transparent, the plate should be moved. The idea is to allow the heat to be evenly distributed over the metal. Each grain should be allowed to become a melted globule (Fig. 4.10) and should not be heated beyond this, or the separate globules will begin to run into each other and the evenness of the grain will be spoiled.

Fig. 2.7 shows two aquatint boxes: The principle is that resin powder is agitated inside them in some way, the plate is slid into the base of the box on a tray, and the dust settles on its surface, much more evenly than if sprinkled by hand. The longer the plate is left in the box, the denser the ground. One box in Fig. 2.7 is operated by means of a kind of paddle, worked from outside by a cranked handle; the other works with a bicycle pump. It is very important to see that aquatint boxes are well sealed, since the flying dust can be harmful if inhaled; and even after a hand-sprinkling session, windows should be opened to clear away grains in the atmosphere.

A plate prepared with an aquatint ground has its edges and its

Fig. 4.10 A ground of melted resin

reverse side protected with straw-hat varnish in just the same way as
one grounded with wax. Also, all those parts of the surface which are
to appear white in the finished print are stopped out with varnish.
The plate is bitten in stages, as in the case of an etching, the areas
bitten for the shortest time printing pale and those bitten longest
printing darkest. The difference is that a weaker acid is required for
aquatint and that the plate is left in the acid for much shorter periods
of time. The reason for the weaker acid (one part of nitric to twenty
parts of water will be about right for a zinc plate) and for the shorter
immersions is that nitric tends to bite sideways as well as down into
zinc and would, if given its head, undermine the tiny crowns of
metal on which aquatint depends for its effect. What should happen
is that each melted globule of resin protects the small area of metal
beneath it, while the acid attacks the exposed metal around it. The
globules of resin are, of course, cleaned off the plate's surface with
methylated spirits before printing begins. When the plate is wiped
prior to printing, the ink is retained in this fine network of crevices –
but only if the crowns of metal are unimpaired. If they are
undermined by an unduly strong acid or by too long an immersion,
there is nothing to retain the ink. No crowns means no intervening
crevices and, instead of the sparkling granular effect characteristic of
aquatint, the result is a weak smear.

Aquatint is frequently used on its own, or with only the finest of
etched lines to demarcate for the printmaker the limits of the various
tones. However, it is just as frequently used with etching, the bitten
lines providing a kind of compositional scaffolding.

SUGAR AQUATINT

The technique of sugar aquatint has been adequately described on

Fig. 4.11(a), (b) and (c) Working proofs of three stages in the evolution of a plate incorporating sugar aquatint and etching

p. 12. It should be pointed out, though, that its advantage – if, indeed, this is an advantage – is that the image painted on to the plate with sugar and ink solution emerges as positive in the finished print. Figure 4.11 will make this clear. Figure 4.11(a) shows a detail of a print made from a plate treated with the sugar-lift method. The building and the sculptures that decorate it were drawn in brush with the sugar and ink solution. Then, the whole plate was given a coat of straw-hat varnish very slightly thinned with methylated spirits. It was applied very quickly and lightly with a broad, soft brush, so as not to disturb the still sticky image beneath. As soon as the varnish was dry to the touch, the plate was placed in warm water and, with the persuasion of a hog-hair brush, the sugar solution was lifted away, revealing the image in bare metal. Then, an aquatint ground was laid, as described above, and the image bitten in three stages – hence the three tones. Subsequently, as can be seen from Figs. 4.11(b) and 4.11(c), etched line and a texture achieved by working fine wire wool into a wax ground have been added.

MEZZOTINT

Drypoint, briefly described on p. 17, needs no further amplification here, but mezzotint certainly requires elaboration. The technique calls for monumental patience and tenacity. As we have seen, the mezzotint engraver proceeds from dark to light: that is, he roughens the surface of his plate so that it will hold so much ink as to print solid black and then, by scraping and burnishing away this roughness to varying degrees, he creates the full range of tones required.

The essentials for mezzotint are the copper plate (zinc being really too soft for the purpose), the rocker (see Fig. 2.5), and scraping and burnishing tools (see Figs. 2.3 and 2.4).

Ludwig von Siegen, born in Utrecht in 1609, is regarded as the originator of the mezzotint principle. His plates, though, were apparently textured largely by means of large, toothed roulettes. The history of the process is obscure, but a close examination of mezzotint prints shows that all kinds of devices have been used to texture plates. There is even evidence of coarse rat-tail files having been rolled over the surface of the copper, driven in deeply by pressing with a piece of wood. It is not possible to say when the rocker first came into use, but tools of that description seem to have been available to mezzotinters for 300 years. At first, the blades were simply equipped with wooden handles and, held like a dagger, the serrations were rocked backwards and forwards across the plate until the surface was densely textured (Fig. 4.12). The print shown in Fig. 4.13 was made from a plate prepared in this way. It would not have been long, though, before the pole apparatus – quite common

Fig. 4.12 A mezzotint rocker

by the eighteenth century and regarded as quite indispensable by the nineteenth – was devised (Fig. 4.14). Lawrence Josset, a mezzotint engraver for many years, can be seen using one of these devices in Fig. 4.15. This particular implement is highly sophisticated, being the outcome of years of experiment by Josset and a predecessor, Arthur Hogg, many of whose tools the former inherited. The rocker blade is fixed to the thicker end of a pole somewhat like a billiard cue – in fact, a billiard cue would do splendidly. At the thinner end is a furniture castor of lignum vitae or brass, or some similar universal joint which will allow the pole to be rocked laterally and, at the same time, to move backwards and forwards in a supporting channel. The channel is at right angles to the table or work bench, to which it is clamped, and it is supported at its far end on a couple of splayed legs. The refinements, though, are many. The blade is not quite at right angles to the pole: It is tilted forward away from it, about 4 degrees out of the perpendicular, and this facilitates its travel across the surface of the copper plate. The end of the pole is weighted with lead, so that the operator need not exert undue

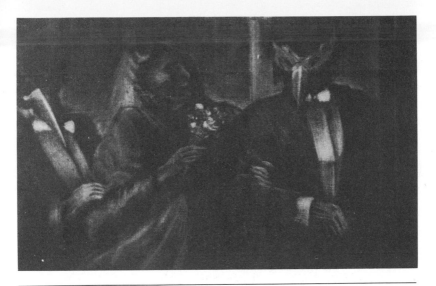

Fig. 4.13 Mezzotint (4⅝ in by 7¼ in) by Lieve Vrancken. The print was made from a plate textured with a hand-held rocker

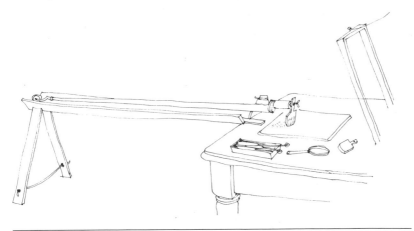

Fig. 4.14 A pole apparatus for mezzotint

pressure. It is also equipped with a small padded vertical handle which serves as a grip for index finger and thumb; and is cranked so that the wrist – and not the pole – is in line with the centre of the notional circle of which the curve of the rocker blade is a part (Fig. 4.16). The curve of the blade incorporates refinements, too. It is not in fact the arc of a circle: such a curve would cause the blade to drive in too deeply at either end; it is a parabolic curve, being more pronounced in the centre and flattening out towards each extremity.

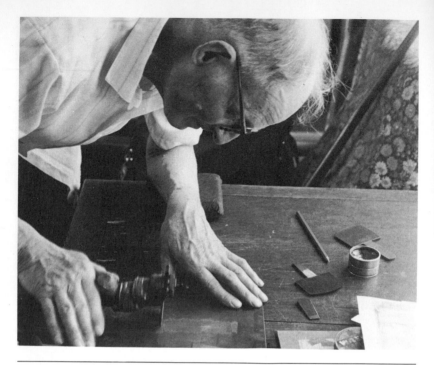

Fig. 4.15 Lawrence Josset working on a copper plate, with a mezzotint rocker fitted to a pole

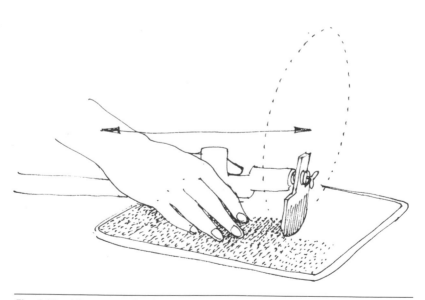

Fig. 4.16 Alignment of wrist and rocker

As well as producing much original work, Lawrence Josset has reproduced a large number of celebrated pictures in mezzotint. Figure 4.17 relates to his plate of the National Gallery's 'Christ Before the High Priest' (Fig. 4.18), painted by Gerard van Honthorst (1590–1656). We can see from this diagram that the copper plate measured 15¾ in by 10¼ in and that it took the engraver seven days to rock the ground ('begun rocking 15th Feb. '58, completed 22nd . . .'). He used a 90 tool – that is, a tool with ninety teeth to the inch – and with this tool rocked the plate in thirty-two different 'ways' or directions (with extra texturing here and there for special effects). These directions are calculated with the aid of a protractor, specially made by the engraver to suit his own needs. The first 'way' is likely to be parallel with the long edges of the plate (Fig. 4.19), and to ensure that the rocking covers systematically every part of the plate's surface, leaving no gaps and avoiding undue overlap, pencil lines are drawn as a guide. The 'ways' (which may be as few as thirty or forty, but are more usually as many as sixty or eighty) are superimposed on each other, so that the plate's texture becomes

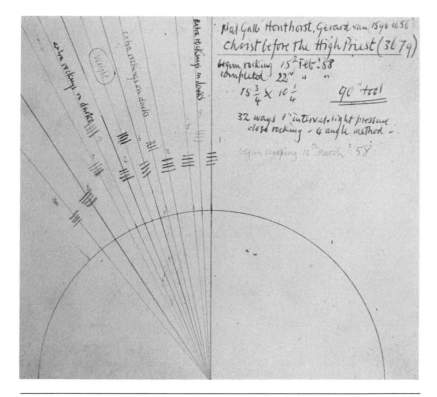

Fig. 4.17 Rocking diagram, Lawrence Josset

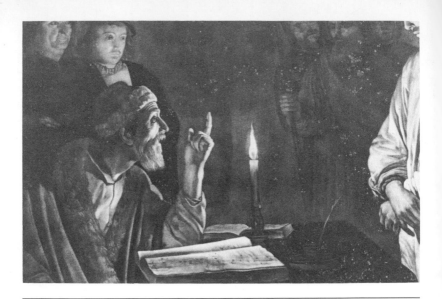

Fig. 4.18 Detail of 'Christ Before the High Priest', engraved in mezzotint by Lawrence Josset after the painting by Gerard van Honthorst

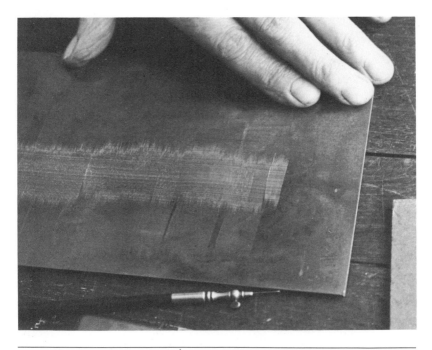

Fig. 4.19 A mezzotint plate being prepared by Lawrence Josset. The 'way' can clearly be seen

denser and denser as the work proceeds. The position of the plate is adjusted after each 'way' has been completed, and fresh guidelines are drawn, so that each new 'way' is at an angle to its predecessor. It is usual, even though the directions may differ by only a degree or two, to allow a larger angle (say, 10–15 degrees) between *consecutive* 'ways', and only subsequently to return to the angles in between. That is, a sequence such as 'ways' 6, 12, 18 etc. is preferable to 'ways' 1, 2, 3 etc. this makes for much cleaner rocking. Across each of the lines radiating from the base of Lawrence Josset's diagram you will see four short strokes. This means that each angle has been rocked in the direction indicated, at right angles to that direction, and both ways diagonally – like the Union flag.

The rocker blade will need sharpening from time to time, and this process is made surer if the tool is clamped for the purpose in a second pole, constructed so that the blade is held at the correct angle to the stone. This pole rests in the supporting channel, as does the rocking pole, and the tool is moved backwards and forwards on the whetstone (carborundum will be suitable) and simultaneously rolled from side to side to make sure the whole of the curve is sharpened. When the blade is removed from the sharpening pole, the bevel having been attended to, the flat, grooved surface is gently rubbed on the stone at an angle of about 30 degrees to remove any slight 'rag' of metal – much as in completing the sharpening of a chisel.

Tools are of various widths ($\frac{3}{4}$–3 in) and of various degrees of fineness, ranging from 25–100 teeth to the inch. Different tools are used in combination to produce rich texture; a combination of a coarse and a fine tool gives a fuller range of tone in the final print than would one tool on its own.

Many mezzotints incorporate the use of acid to get extra depth of tone for shadows and other dark passages, acid being capable of bitting more deeply than the teeth of a rocking tool can be driven in. One way of preparing a ground for biting is to coat the plate with hard varnish (straw-hat varnish thinly brushed will do), and rock with just enough pressure to pierce through to the metal. The biting can then proceed, controlled in the same way as for an aquatint (p. 12, above). Another way is to rock the bare metal, remove the raised burr with a scraper, and lay a thin ground of hard wax with a roller (p. 41, above). As with the varnish ground, the specks of bare metal can then be bitten to varying degrees, stopping-out varnish being applied from time to time.

As always, the image to be printed may be established in various ways. Some printmakers will wish to work freely and directly with a scraper; others will wish to indicate the main lines of their intended design on the grounded plate with soft pencil; and others may prefer to transfer to the plate a previously worked-out drawing, using carbon paper and a metal tracing point. Lawrence Josset's method of reproducing a painting is to have a reversed photograph made of the

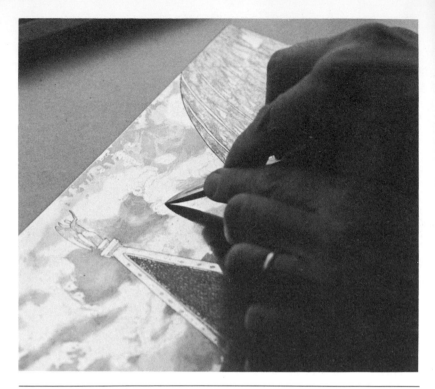

Fig. 4.20 Using a scraper

original; he then traces the composition through carbon paper on to his prepared plate, and is ready for scraping.

The usual scraper has a triangular cross-section (see Figs. 2.3, 2.4), but – and this is true of so many artists and craftsmen – the engraver will often devise tools to his own liking. The standard triangular scraper has grooves in each surface; these facilitate sharpening, since surfaces separated in this way can more easily be made to lie flat on the carborundum stone. While removing metal, the scraper must be held firmly, the handle in the palm of the hand and the thumb and first two fingers close to the cutting edge. Some printmakers find it comfortable to steady the working end of the tool with the forefinger of the left hand (see Fig. 4.20). The cutting edge is almost invariably pulled towards the body, planing away the raised burr of the plate. As the burr is planed away and the scraper begins to descend to the hollows beneath, the tones in the resultant print will be paler and paler. Aquatint plates may, incidentally, be scraped in the same way (see Figs 4.21 and 4.22).

(a)

(b)

Fig. 4.21(a) and (b) Two proofs from an etched and aquatinted plate. The proof shown in (a) was taken after the sky had been modified with scraper and burnisher

The burnisher is infrequently used by the craftsman experienced in handling a scraper; the latter is usually sufficient. Nonetheless, highlights can print more cleanly if the metal is given a final smoothing with the burnisher (Fig. 4.23).

Fig. 4.22 Detail of the scraped and burnished plate from which the proof shown in Fig. 4.21(a) was taken

Fig. 4.23 Using a burnisher

CHAPTER 5

Paper and its preparation

DAMPING THE PAPER

Paper for intaglio printing needs to be damped so that it becomes supple enough to be pressed into, and to pick up ink from, the deepest of a plate's recesses and from the finest of its grooves. The damping must be done with great care; the precise method will depend on the degree of absorbency and the structure of the particular paper being used. It is usual to prepare the paper the day before printing, passing it sheet by sheet through a wetting trough (see Fig. 5.1) and piling it on an adjoining surface. Next, the whole stack is placed between sheets of plate glass or heavy zinc, with a weight on top, so that each sheet is fully permeated by the time printing starts. A trough is not absolutely necessary, however: paper can be thoroughly wetted on both sides with a soaked sponge and laid piece by piece on the plate glass or zinc and then weighted and left. The paper should be swabbed very gently with the laden sponge; vigorous rubbing may well damage its surface. Some printmakers recommend sponging both sides of the paper and finally, turning the sheet once more, sponging it out flat on the glass. This is a particularly good idea where heavy papers are concerned. The sponging should be done from the centre of each sheet out towards the edges, so that air pockets are excluded and so that each sheet lies flat on the pile.

Most paper is treated with size. The more heavily sized the paper, the more soaking it will require. The amount of size in a sheet can easily be gauged by moistening a finger end and dabbing it on a corner: if the moisture is absorbed at once, as if by blotting paper, there is little or no size present; if the moisture does not readily disappear, the paper is likely to be quite heavily sized. Direct sponging, as described above, is suitable for most normal sized papers; but for unsized, lightly sized or very thin papers, a different approach is necessary. If such papers were to be so much as touched by a sponge they would buckle and curl uncontrollably. A safe way to damp such papers is to prepare a pile of sheets of white blotting paper, slightly larger than the printing paper, to damp them, to

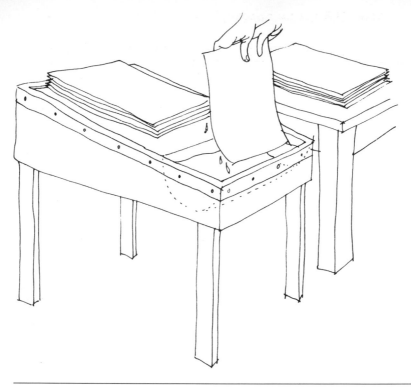

Fig. 5.1 A wetting trough, zinc-lined

interleave them with the dry sheets of printing paper, and to place
the whole stack under glass and weights overnight as for heavier
papers. The best way to damp the blotting paper is to put half the
number of sheets under the tap, interleave them with dry sheets, and
put the pile under glass and weights for an hour before proceeding
with the interleaving of the printing paper. A couple of sheets of
printing paper between each sheet of damp blotting paper is about
right; but very thin papers can be inserted half a dozen at a time.

HAND-MADE PAPERS

Hand-made papers may still be bought from such establishments as
Hayle Mill, near Maidstone in Kent. The mill is run by Barcham
Green & Co., paper makers since 1805, and its entire output is hand-
made. Such paper, made from rag, is of excellent quality and prints
made on it are likely to survive for centuries. But hand-made paper
is not necessarily the easiest to print on; some modern machine-made
papers accept ink quite beautifully.

MACHINE-MADE PAPERS

The first paper-making machine in Britain was set up at Frogmore near St Albans as long ago as 1803; it was the invention of the brothers Henry and Sealy Foudrinier. Within three years, about twenty of these devices were producing between them a large proportion of the country's annual paper output. By the 1830s the consumption of machine-made paper was prodigious; and since those days, the hand-made product has become scarcer and scarcer. This is hardly surprising: the heavier the demand, the greater was the urge for speed. The nineteenth-century records of publishers and plateprinters are full of references to their search for paper of good quality. The machine-made variety was at that time too hard for plateprinting purposes and manufacturers were too ready to use bleach and other chemical additives detrimental to durability.

Happily, there exist today various sympathetic machine-made papers. While none is very cheap, they are nonetheless a fraction of the price of their hand-made counterparts. There is, for instance, a textured cartridge paper called Bockingford. This can be bought in various weights, but that referred to as 200 lb is about right: it has a pleasant, robust feel to it. Bockingford needs to be sponged, piled and left overnight under weights; but there is another extremely useful paper which can be damped a mere half hour before printing. It is known as Cornwall Cover, and is supplied in white and in ivory. This, too, comes in various weights, but the heaviest is best. Another paper worth trying is Heritage Book White. These are just a few examples of relatively inexpensive papers which print satisfactorily; but individual printmakers will want to search for their own favourites. Many firms supply samples, and with these one can experiment to find those that satisfy from the aesthetic as well as from the practical point of view.

If the paper is to accept ink properly it must be neither too dry nor too wet. If it is found to be too dry, the only solution is to damp the whole lot again; if it is too wet, the surface of each sheet may be lightly flicked with a soft brush until the shine of surplus water has disappeared or, alternatively, each sheet can be dabbed with clean blotting paper, though this is a tricky procedure when one's hands are inky. When the degree of dampness is right, the sheet of paper should feel cold and slightly clammy to the cheek or the back of the hand. As in all other aspects of intaglio printing, the only way to get the damping right is to accumulate some experience – and to risk making some mistakes!

The press

The press for intaglio printing is often called an etching press, or a copper-plate press. For obvious reasons, both of these terms can be rather misleading: the press is for printing plates etched, engraved, drypointed or worked upon in any intaglio technique; and it will take plates of any metal. The term rolling-press is therefore probably most straightforward.

THE PRINCIPLE OF THE ROLLING-PRESS

The rolling-press is basically a very simple machine. It consists of a flat bed or plank (as it is still called, even when made of metal) that runs between two rollers, carrying with it the inked plate, the damped paper and the resilient woollen blankets which will press the paper into the plate's crevices. The rollers are supported at a convenient working height in a rigid framework, and are driven either by up to six spokes radiating from a spindle in the upper roller or by a system of flywheel and gears.

Second-hand rolling-presses are now very difficult to obtain and are usually very expensive, though a generation ago they could be bought for next to nothing. In 1956, when the celebrated printing house of McQueen (see Fig. 6.8) closed down after over 150 years in the plateprinting business, the firm's rolling-presses were sold at £1 an inch; that is, £1 per inch of roller length. A machine which would then have been sold for £30 could today easily cost £1000. The golden age of rolling-press manufacture was from about 1830 to about 1880, and many machines made during that time are still in use in art schools and workshops all over the country. Such is the demand for presses, however, that small specialist engineering firms such as that of Harry Rochat, of Barnet, Hertfordshire (see Fig. 6.1), are now producing a steady stream of new machines. The simple efficiency of the traditional model has never been improved upon, and the best new machines adhere closely to nineteenth-century prototypes. One firm in the outskirts of Paris (Roger Ledeuil of

Fig. 6.1 *A press recently manufactured by Harry Rochat and, right, a mangle suitable for adaptation to intaglio printing*

Montrouge) still produces presses of nineteenth-century design (Fig. 6.2), but has also devised a much lighter machine, the framework of angle-iron strengthened with bolted sheets of metal, and the rollers driven with the aid of something resembling a bicycle chain. The records of British patents are littered with accounts of attempts to improve on the simple traditional rolling-press but, apart from the adding of gears and the gradual adoption of iron to replace wood, there has been little useful change in design since the seventeenth-century (see Fig. 6.3). Other manufacturers have, like Ledeuil, experimented with innovations, but these are usually in the interests of lowering prices, and the result is all too often excessive flimsiness of frame and plank, rollers which are too puny, and an action anything but smooth.

TABLE PRESSES

If nothing more substantial is available, one might have to resort to a table model, and these are not uncommon. An etcher named P. G. Hamerton (1834–94) invented a tiny press which, he claimed, 'an etcher might put in his box and use anywhere, in an inn, in a friend's house, or even out of doors when etching from nature'.

Fig. 6.2 *Assembling a new press of traditional design, the Ledeuil factory, Montrouge, Paris*

WOODEN PRESSES

Until about 1830 all rolling-presses were made of wood. We can get a fair idea of the kind of press Rembrandt, for instance, must have used if we look at Fig. 6.3, a depiction of a wooden press from the manual of the seventeenth-century French plateprinter Abraham Bosse. Similar presses were used all over Western Europe at that time, and examples still survive. There is a splendid machine – also dating from the seventeenth-century – in the Plantin-Moretus Museum in Antwerp. There is another (Figs. 6.4, 6.5) at the Paris workshop of Jacques Frélaut, the craftsman who assisted Picasso with many plates, and who set up a printing studio at the artist's house. You can see clearly from the Bosse illustration (the original is itself an etching, incidentally) how the press is driven by four spokes or arms, radiating from the spindle of the upper roller. The plank needs to travel smoothly between the rollers – a jerky passage can result in uneven printing – and, to achieve this, the printer uses his foot to keep the press rolling while he changes hands from spoke to spoke.

Fig. 6.3 A wooden rolling-press. Plate 16, Abraham Bosse, 1645 (St Bride Printing Library, London)

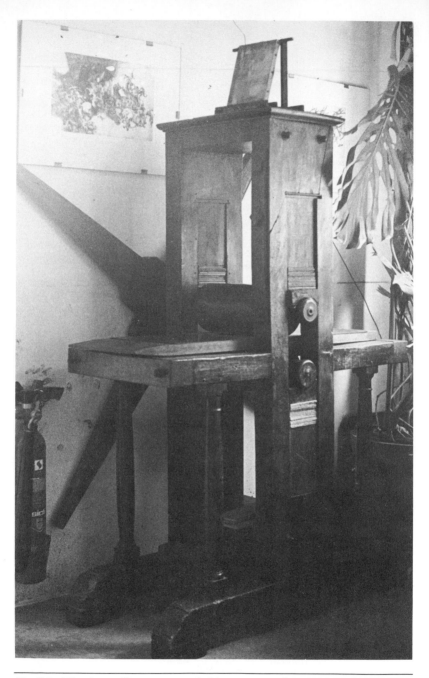

Fig. 6.4 Wooden rolling-press, probably seventeenth century, at the Atelier Lacourière et Frélaut, Paris

Fig. 6.5 Detail of the bearings and packing of the press shown in Fig. 6.4

A press like this, with four arms, is called by the French a *presse à croisée*, and by English printers a cross-press. A press with five arms is often called a star-wheel (Fig. 6.6) and one with six or more a spider-wheel press. The framework of these wooden presses was usually made of oak, the plank of walnut, and the rollers of elm or of lignum vitae. If oak was unobtainable, the framework could be made of elm; planks were frequently made of mahogany instead of walnut; and rollers could sometimes be made of walnut. Wooden rollers were soaked initially in linseed oil to prevent splitting, and they were subsequently kept in condition by occasional rubbing with an oily rag. Planks were about 2 in thick and were tapered at one end to allow easier insertion between the rollers. There were planks of different sizes available to each press, to be used according to the scale of the work. As they wore – and small plates were particularly damaging in this respect – their hollows were compensated with paper packing. Eventually, when the hollow became too pronounced, the only solution was planing; but this would lead ultimately to the plank becoming too thin and having to be replaced. Even the bearings of these presses were wooden, as you can see from the photograph of the Frélaut press (Fig. 6.5), though Abraham Bosse recommended lining them with sheets of polished iron, for durability. You will see from both Figs. 6.3 and 6.4 that the side members (or cheeks) of the press are pierced by openings which hold the bearings which, in turn, support the spindles of the rollers. Pieces of card, thick paper or leather, and sometimes felt, neatly trimmed to fit, act as packing, and it is this packing which controls the pressure. The printer would adjust this according to the thickness of the plate he was to print from, and the pressure would have to be attended to each time a new plate was to be used – that is, if there was any variation in the thickness. Some of the more sophisticated presses had screws operating vertically downwards through holes drilled in the framework, and the pressure could more conveniently be controlled by means of these.

Wooden presses must have been quite efficient, judging from the evidence of the many hundreds of thousands of technically excellent prints they yielded. There thus seems no reason why a heavy mangle of the kind shown in Fig. 6.1 should not give good results. The rollers of such a mangle should be wooden rather than rubber and, if worn, they can easily be turned on a lathe. Given a soaking in linseed oil, they will be ready for work. A plank can be made from $\frac{1}{2}$ in chipboard, and an arrangement of slender wooden rollers at each end will keep it from sagging as it travels backwards and forwards.

Some wooden presses were still in use many years after the first iron presses had begun to appear. At least one has survived in Britain. It was acquired in 1875 by Charles William Sherborn, the engraver, who used it until 1912, and it is now on display in the Science Museum, London (Fig. 6.7). This press is thought to have

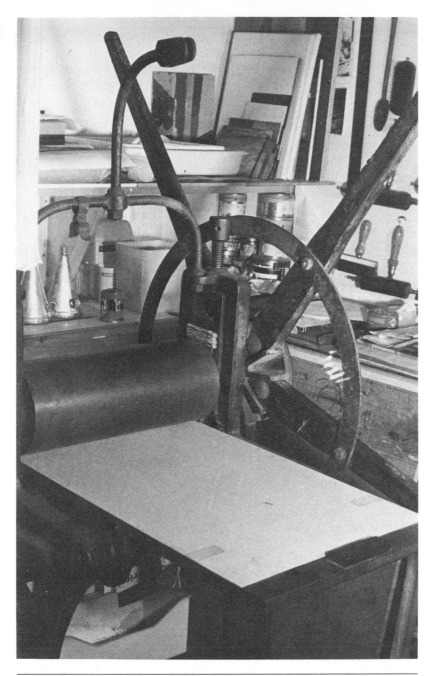

Fig. 6.6 An ungeared Furnival star-wheel press in the author's workshop

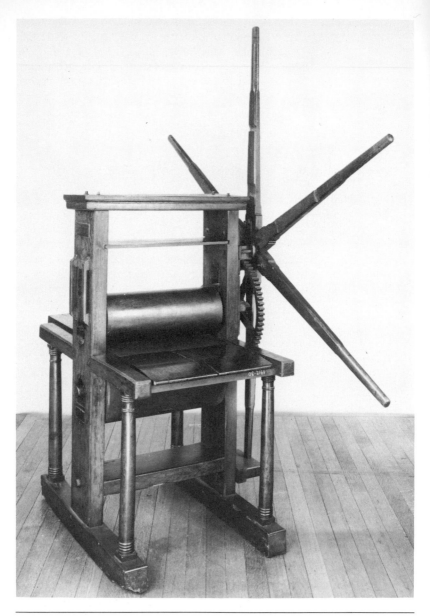

Fig. 6.7 Wooden rolling-press, probably eighteenth-century, with wheel and pinion gear added at a later date (Science Museum, London)

been made in the eighteenth-century, but several refinements have been incorporated since. For example, a simple gear was fitted – probably during the nineteenth century – to lighten the work of hauling on the six radiating arms. The upper roller of this press is

9 in diameter and the lower one 12 in, and both appear to be made of lignum vitae. This variation in diameter is interesting: while many presses have rollers identical in thickness, there is a theory that the bottom one needs to be larger in diameter for maximum gripping power. Some press builders insisted on precise relative proportions: the lower roller, they felt, should be exactly one-fifth larger in diameter than the upper one.

THE DEVELOPMENT OF THE IRON PRESS

Another even more interesting survivor from the nineteenth century is the plate printing firm of Thomas Ross & Son, whose workshop in Putney is shown in several of the illustrations in this book. The firm was established (as Dixon & Ross) in 1833, and detailed records of its transactions since that time have been preserved. We can glean from these records fascinating insights into the transformation of wooden presses to iron. They contain, for instance, references to elm rollers being taken away and replaced by iron substitutes, and details

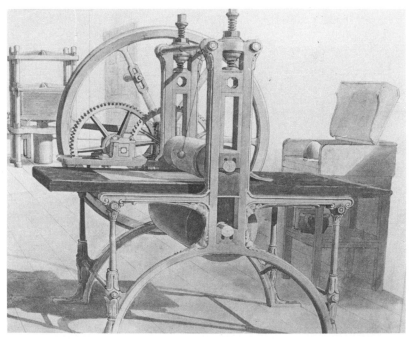

Fig. 6.8 An iron press with gears, fly-wheel and a mahogany plank. Detail of a wash-drawing (17 in by 28 in) by George Brookes, 1832, of the new McQueen workshop at 184 Tottenham Court Road, London (colour frontispiece in Bain, 1966) (Ross Collection)

of the adding of gears to presses. All this was happening during the 1830s, and Fig. 6.8 shows us what a thoroughly up-to-date machine of those years looked like. The view is of the interior of a new workshop built in 1832 for William McQueen, in Tottenham Court Road, London. The press, a graceful iron machine, is fitted with a large fly-wheel and gears, and one of the spokes of the fly-wheel is pierced by an elongated socket so that the position of the turning handle may be altered to suit the individual operator. The press is shown with a mahogany plank, on which is a small plate with the paper laid over it, ready to print; and, to protect the plank, a large sheet of zinc has been placed under the plate. The felt press blankets are in position over the roller, held in place by a heavy brass ball suspended from the cross-member of the press. Although this is something very seldom seen today, holding the blankets against the roller in this way was common practice in the nineteenth century; it lessened the risk of wrinkling. Nowadays, most printers keep the blankets flat on the plank, as Abraham Bosse's printer did (Fig. 6.3). William McQueen's press is fitted with large pressure screws with hexagonal heads, which could be tightened or slackened with a spanner; and the bearings, cut away to reduce friction and to make oiling easier, are of brass. The bottom roller is gigantic: its diameter seems to be at least 12 in – about twice that of the upper roller. Such

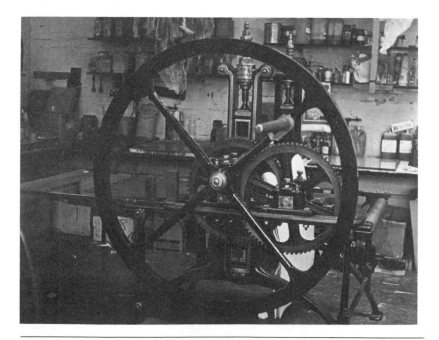

Fig. 6.9 Iron rolling-press, probably 1830s, with gears, fly-wheel and metal plank (Editions Alecto Limited, London)

machines were virtually indestructible, and there are still a number to be seen, working as efficiently as the day they were made. Figure 6.9 shows a press, almost identical to William McQueen's, on which the original mahogany plank has been replaced by one of steel but, apart from that, there is very little difference. The press is owned by Editions Alecto of London, and was made about 150 years ago by an engineer named Flanders.

Figure 6.10 shows part of an illustration from a French plateprinter's manual of 1836. The authors, Berthiau and Boitard, describe this press as one in common use in France at the time. If you compare it with Fig. 6.3, you will see that it is very similar to that of Abraham Bosse, 200 years earlier. The diagram contains several interesting details: the blankets are held back over the roller by means of a weighted tape pinned to one edge; the vertical openings in the cheeks are much larger than those of the Bosse press, and contain much more packing; the packing, the authors tell us, consists of thin squares of card punctuated at intervals by squares of felt for extra resilience. And, in the top right-hand corner of the illustration, we can see a detail of a simple gear known as a wheel and pinion; the Science Museum press is fitted with a similar gear (Fig. 6.7). The pinion, sometimes called the lantern, is fixed at the intersection of a press's arms and engages with the toothed wheel to lighten the work of hauling on the press. Another advance on the design of Bosse's day is that the wooden presses of the early nineteenth century were sometimes fitted with rollers of cast iron or of brass.

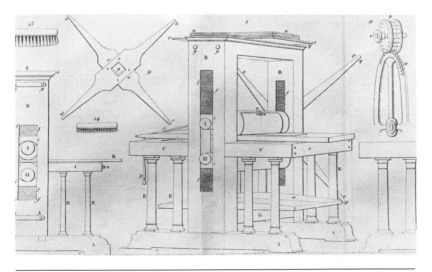

Fig. 6.10 Diagram of a wooden ungeared rolling-press, with details of packing, bearings and cross. Detail of Plate 1, Berthiau & Boitard, 1836 (St Bride Printing Library, London)

By halfway through the nineteenth century, very large steel plates had become quite common, many of which approached 8 ft^2 in area, and larger and heavier iron presses were devised to cope with this increase in scale. Figure 6.11 shows several late nineteenth-century presses at the workshop of Thomas Ross & Son.

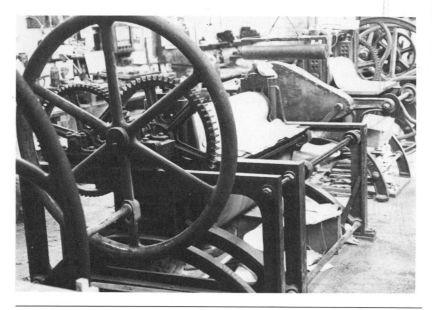

Fig. 6.11 Late nineteenth-century presses in the workshop of Thomas Ross & Son (Ross Collection)

PREPARING THE PRESS FOR PRINTING

Whatever kind of press may be available, using it methodically is essential. Anything from three to five blankets is usual. Blankets are of two kinds: thin and compact in texture, called 'fronting'; and thicker and springier, called 'swan-cloth'. Two layers of fronting and one of swan-cloth will do. The blankets should be an inch or two narrower than the plank, and several inches shorter. It is quite a good idea to cover the plank with a sheet of Formica; This can simply be taped in position (see Fig. 6.6), and the advantage is that it can easily be wiped clean between prints. In preparing the press, the plank should be run out as far as it will go. It should be equipped at each end with some device to stop it coming out altogether from between the rollers. Obviously, serious accidents can happen if a steel plank falls, and should you find yourself using a press without these safeguards, a piece of solid rubber or of hard

wood can be glued at each end of the plank with a strong adhesive like Araldite. The blankets should be laid one by one on the extended plank, first the fronting and then the swan-cloth. The plank should then be run back so that the blankets are just nipped beneath the top roller. They can then be turned back over the roller, smoothed into position one by one. This needs to be done extremely carefully, so that there is not the slightest danger of creasing. There is a mention, in some early accounts of plate-printing, of blankets placed *beneath* the plate as well as above. This is never done nowadays, though some printers do like to place a piece (or several pieces) of blotting paper beneath the plate, trimmed exactly to its dimensions.

ADJUSTING THE PRESSURE

To get the pressure right, the un-inked plate should be placed on the pad of blotting paper, its position marked in pencil at the corners so that it will be in precisely the same place throughout the printing run. Where the corners of the printing paper will be positioned can also be marked, either in pencil or with adhesive tape. Next, a piece of damp paper or a sheet of dry blotting paper is laid on the plate. Some printers place a sheet of acid-free tissue paper on the back of the damp printing paper to prevent the blankets getting too wet. The plate is then taken through the press. During its passage, the blankets can be laid flat, as in Fig. 6.3, or they can be held back over the top roller. At Thomas Ross & Son, the blankets are kept in position over the top roller by means of a heavy wooden roller in an iron frame, slung by a length of cord from the ceiling (see Fig. 7.4); some printers tie the blankets edge to edge round the roller with tape; and, as we have seen, blankets were in the past held back by a brass ball or by a weighted lanyard. The paper should be lifted from the plate, and the imprint carefully examined. Most important are the marks of the lateral edges of the plate: they should be evenly impressed; but if they are not, this means that the pressure is uneven and the press needs to be adjusted accordingly. It is better not to force the pressure screws down too violently; simply to regulate them so that the sunken plate mark on the trial impression is equally firmly embossed on both sides and so that all the work on the plate is crisply reproduced. Once the screws are in harmony they are best left alone, and fine adjustments to pressure can be made by reducing or increasing the number of pieces of blotting paper beneath the plate. Should a particular area of the plate not be clearly embossed in the paper, this *could* mean that the paper is unevenly damped; but it could also mean that there is a slight concavity in the plank of the press. The position of the suspected hollow should be estimated and

a piece of cartridge paper, torn so that its edges are feathered, should be placed in the appropriate spot, between the plank and the Formica. Once you get a blind print with evenly embossed edges and with sharp detail over the whole surface, the press is ready and printing can begin.

Printing

Once the press has been prepared, the pile of printing paper checked for correct degree of dampness, and the tissue paper – if it is to be used – trimmed to size, the work of printing can begin. The importance of this final stage in the production of a print cannot be too strongly emphasised: a skilful printer can enhance the effect of an indifferent plate; a clumsy printer can all too easily spoil the impressions taken from even the best of plates. Frederick Goulding, an apprentice plate printer in the mid-nineteenth century, was fascinated by the printing technique of the American artist James McNeill Whistler (1834–1903). The artist brought his plates to the London workshop where Goulding was employed, and the young printer learned, watching Whistler print, 'that there was something in the printing off a plate beyond the mere filling of its lines with ink and the cleaning with hand and whitening . . . that something of the artist's mind could pass through his fingertips to the inanimate copper' (Hardie, 1910). The subtlety of intaglio printing has probably never been expressed better. The printer of intaglio plates can extend the creative process right to the last flick of his palm on the plate. Printing, claimed the Jury of the 1855 Paris Universal Exhibition, is to the engraved plate as musical performance is to composition. This stresses again the idea of *interpretation*. It is the very nature of the intaglio plate that gives full scope to interpretation: the fact is that an engraved plate prints intaglio *and* relief simultaneously. The pressure of the rollers, the resilience of the blankets, and the suppleness of the damped paper combine to produce what is virtually a cast of the plate; and however thoroughly the plate's surface is wiped after ink has been deposited in its crevices, it still transfers the lightest of films of ink to the paper. This film can be controlled by the strength or restraint of the wiping; and in this way, tones of various depth can be distributed about the plate's surface to enhance the composition of the eventual print.

Preparing the ink

The first thing is to prepare the ink (Fig. 7.1). Many printers grind their own inks, and this is a procedure that has changed little since it was described by Abraham Bosse (whose press we have seen in Fig. 6.3) in 1645. He tells us that 'the black should be ground on a marble slab with a good large muller, about half a pound at a time, and the weakest oil should be added. If the plates are worn, or the engraved lines shallow, the ink may be on the weak side. It is vital to match the consistency of the ink to the character of the plate – above all to avoid undue thinness . . . to ensure that the pigment will transfer more readily to the plate.' Many printers attach importance to the matter of colour as well as to that of consistency, even when restricting themselves to black. Perhaps it would be clearer if we were to use the word 'temperature' instead of colour. Some blacks can be warm – slightly brownish – and others cold – slightly blue; some, of course, may be quite neutrally, densely, black. It is well worth experimenting with these 'temperatures'. E. S. Lumsden, in his manual, tells us that a delicate etching requires a warm ink, while a deeply bitten plate needs a cooler pigment; but this is really a matter for the individual to decide. It is not unusual for a printmaker to use different 'temperatures' or different strengths of ink on the same plate: perhaps a cool black for the distant parts of a landscape, and a warmer pigment to bring the foreground into prominence.

Fig. 7.1 Ink ready for use

Bosse refers to weak oil. The oil used for intaglio ink is available in various consistencies—weak, medium and strong – according to the length of time it has been burned. At one time, printers prepared their own oil; and Bosse has left us an interesting account of this process, too. His instructions are to pour the oil into a large iron pot, and then to 'place it over a good fire, and let it boil, but watch it carefully, since the house could catch fire'. In fact, oil-burning was the cause of so many fires that it was eventually banned in London. 'Keep stirring', continues Bosse, 'until the oil itself catches fire and then remove it from the heat. It may burn for half an hour or more, after which you should let it cool a little and pour it into storage vessels. For stronger oil, burn a good deal longer, stirring until it becomes thick.' Ink made with the strongest oil is extremely difficult to wipe from the plate, and it is therefore better for inexperienced printers to restrict themselves to weak and medium oils. Another convenience in using less sticky oils is that is is not so essential to have a hotplate.

A lithographic stone is the best surface for grinding ink, though a slab of marble or of heavy plate-glass will do. The black powder (likely when bought to be labelled 'Light French' or 'Heavy French') may be mixed dry with a little burnt umber or prussian blue if the 'temperature' is to be modified. Then, a small hollow should be made in the pigment, and a little weak oil poured in. The ink should be mixed with a palette knife to a firm, smooth paste: firm enough to just sag from the knife when it is held aloft, though not to run from it. If the ink seems too thin, more pigment and perhaps a few drops of heavier oil can be added. Then, the muller should be taken in both hands, and the ink ground thoroughly between its flat surface and the surface of the slab with a pushing and pulling movement. As the muller is pushed, its leading edge should be lifted slightly so that the ink is driven forward in the acute angle thus formed; as it is pulled, the edge nearer the body should be tilted so that the ink is brought back in a similar way. When all vestiges of grittiness have gone, the ink is ready for use; inadequate grinding will certainly lead to scratched plates.

It is more convenient to buy ink in tins or tubes; but even prepared ink may need to have a little oil added, to get the right consistency for a particular plate – or for a particular day, since the ink naturally stiffens in low temperatures. Charbonnel of Paris make a particularly good tinned ink (Fig. 2.8) which is quite easily obtainable in this country.

Before printing, any protective varnish should be removed from the back of the plate with an appropriate solvent; lumps and ridges of solidified varnish can buckle a plate as it goes through the press. It is also a good idea to polish the plate's surface with Brasso: this makes the inking and wiping easier.

Inking the plate

The plate may next be warmed (though, as we have seen, this may
not be necessary), and the ink applied. Ink can be worked into the
plate's crevices with either a dabber or a roller, and both implements
are much more effective if covered with fine 'fronting'. A square of
'fronting' can be stretched over a dabber and lashed in position with
string round the handle; or a piece of the same material can be
stitched round a roller (see Fig. 2.11) so that its edges just meet,
thus avoiding a clumsy seam. The roller may be of hard rubber –
this works perfectly well when covered with the felt – or may be a
softer gelatine roller. If the dabber or the roller are used frequently,
there is really no need to clean them after use; they can simply be
scraped with a knife and hung above the work bench, ready for the
next printing session. If they are left like this for two or three days,
no harm will be done. If, however, weeks elapse between printing
sessions, the ink will harden and the 'fronting' will need to be
renewed. Of the two implements, the roller is really preferable: it is
quicker and less likely to scratch the plate should any grit have
remained in the ink. The ink should be picked up from the slab,
coating the roller quite thickly in a spiky texture, and should then be
worked vigorously into the plate's surface, rolled in various directions
so that all the crevices are filled.

Wiping the plate

At this stage, the majority of printmakers will remove surplus ink
from the plate with a large pad of stiff muslin, or scrim. However,
there seems to be little point in clogging the scrim with ink to an
unnecessary degree; I find this initial removing of the ink is done
much more satisfactorily with a small scraper of rubber of some other
suitably flexible composition. I use a piece of screen-printing
squeegee rubber for this purpose; it is about 5 in by 3 in and a
quarter of an inch thick, and it does the scrim's job quickly and
cleanly. That is, it clears surplus ink from the surface of the plate,
and it simultaneously ensures that any crevices missed by the roller
are filled. The ink that builds up on the edge of the rubber during
this operation can be scraped off and replaced on the inking slab,
where it will be of much more use than lodged in a pad of scrim.
Ink, particularly prepared in tins, is horrifyingly expensive, and the
saving that can be made by using a scraper rather than scrim at this
stage of printing is really quite considerable.
 However, there will be printers who prefer to use the traditional
method of shifting the ink with scrim; and, in any case, once the
major part of the pigment has been removed – by whatever means –

the rest of the job must be done with the scrim. The stiff scrim is loaded with size, and this must be loosened and shaken out before the material is used, otherwise it could scratch. A piece about 24 in² should be torn from the roll and rubbed between the hands until the flakes of size are loosened enough to shake away. The scrim is next shaped into a flat pad. The first shifting of the ink is done with a strong, scrubbing action. The action should come naturally if one remembers the purpose of this: to remove ink from the surface and to make sure it is thoroughly pushed into the crevices.

It is best to prepare a couple of pads of stiff scrim and one of soft before before starting work. The first can be used for the initial removal of ink (that is, if the alternative of a rubber scraper is not preferred), the second to clear most of the remaining ink from the surface of the plate; and the soft scrim to begin the process of polishing the metal. The second wiping needs to be lighter than the first. By this time, all the plate's depressions are laden with ink, and this should not be scooped out. So, the pad of scrim should be kept flat, should be shaken out and turned from time to time, and should travel in a figure-of-eight movement across the surface. This movement clears the ink away more effectively. When this wiping is completed, the metal will be gleaming through a very thin film of ink. The process can then be repeated with the soft muslin until the plate's surface seems quite clear of ink, the bevelled edges are cleaned (Fig. 7.2) with some cotton rag wrapped round a finger end, and everything is ready for the hand-wipe.

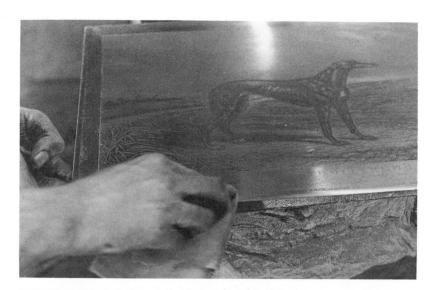

Fig. 7.2 Cleaning the edges of a plate, Thomas Ross & Son (Ross Collection)

The hand-wipe

No intaglio printer can avoid inky hands and the final wipe with a bare palm is absolutely indispensable (Fig. 7.3). Rubber gloves are useless, since it is the ridged texture of the skin on the heel of the hand that is needed to dislodge the last vestiges of ink from the plate's surface. In hand-wiping, some printers use the whole palm; others use the heel of the hand. I find it most effective to use just the soft pad of flesh that extends from the base of the little finger to the wrist, holding the hand with the palm at about 45 degrees to the plate. For the hand-wipe, the plate is slid from the heater (if heat has been used in the inking) onto the neighbouring gigger. The hand is passed over a block of whiting, or dabbed into a saucer of powdered whiting, and then rubbed over a piece of cotton rag tucked into the front of the printer's apron. Too much whiting will clog the plate; just the right amount – the merest film – makes the final polishing process so much more effective. Hand-wiping is done from the shoulder: the whole arm must be loose and relaxed so that the palm can travel with a swift, flicking action across the metal. This business of the hand-wipe has been surrounded with mystique; it has even been claimed that an apprenticeship of several years is needed properly to master the skill. There is certainly a knack to it, but

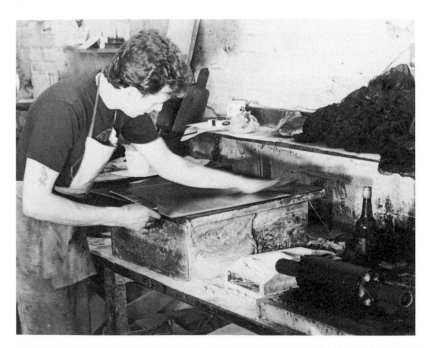

Fig. 7.3 Hand-wiping a plate, Thomas Ross & Son (Ross Collection)

Thomas Ross & Son seem able to train their printers in a matter of
weeks.

Controlling the plate tone

It is at the hand-wiping stage that the subtle variation of surface tone
can be brought about. Some parts of the surface may be left scarcely
wiped at all, so that a darker passage in the print is intensified; other
parts may be wiped so thoroughly that highlights are created in the
composition. There are further ways, too, of manipulating light and
dark. Small areas can be wiped with whiting on a finger end, or with
clean, soft muslin round a finger, rather than with the whole hand.
And passages of cross-hatching (like the sky in Fig. 4.11) can be
softened by trailing the point of a pad of muslin across it, so that a
little ink is dragged out of the crevices.
 A large, heavy plate will stay in position on the gigger while
being wiped. However, a small plate is more difficult to control. One
way is to press the thumb of one hand against the front edge of the
gigger while wiping towards the body with the other, thus keeping
the plate from skidding off.

The printing

A final warming of the plate before positioning it on the plank of the
press can ease the transfer of ink to paper. A quick, light flicking of
the paper's surface with a soft brush will not only take care of
surplus moisture, but will also raise its texture and contribute still
further to the effectiveness of the printing. The paper, handled with
a pair of *poucettes* or card pincers, is positioned according to the
registration marks which will already have been made on the plank.
There is always a 'right' side and a 'wrong' side to a sheet of paper,
and it is of course important to lay the paper 'right' side down on
the plate. In the case of a machine-made paper, the printing surface
is likely to appear less regular in texture, and its reverse side may
have a more mechanical, woven look. Hand-made papers, whether
hot-pressed (smooth) or 'not' (rough), will almost always be water
marked, and the printing surface can easily be identified by this
means. A sheet of tissue paper (to prevent the blankets getting too
wet) is next put over the back of the printing paper, and the blankets
are either laid one by one and smoothed into position over plate and
paper or, as described above (p. 76), are turned back over the upper
roller of the press.
 There should be no problem concerning the pressure at this

stage: this will have been established previously with the aid of the un-inked plate. As the press is operated (Fig. 7.4), the plank will move forward quite freely until the leading edge of the plate meets the upper roller; then, you will feel some resistance. In the case of a large press with gears and a heavy fly-wheel this will be less pronounced than if one is using, say, an ungeared star-wheel press like the one shown in Fig. 6.6. But, whatever the machine, the moment when the plate comes under pressure is unmistakable; and, if the blankets are held back over the upper cylinder, you can see that moment approaching. The plate must then be taken through the press steadily and smoothly. With a geared press this is less difficult than with an ungeared model. With something like an ungeared star-wheel, you have to use feet as well as hands (just like Abraham Bosse's apprentice, Fig. 6.3) to keep the plank moving forward, never allowing it to stop for a moment until the plate has completed its journey. If the plank *is* halted, there is a risk of spoiling the print with a disfiguring bar where the roller has rested.

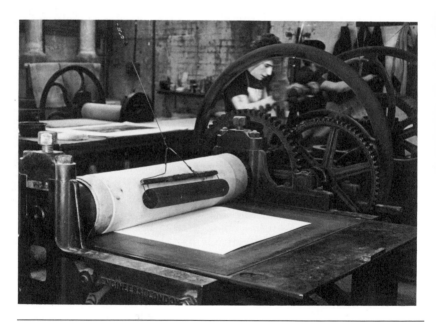

Fig. 7.4 Taking a plate through the press, Thomas Ross & Son (Ross Collection). Note the wooden roller, suspended from the ceiling, holding back the blankets over the impression cylinder

The plank should be taken far enough through so that the edge of the printing paper is no longer nipped beneath the roller and the blankets thrown back so that the print may be lifted. There is a trick to throwing the blankets back over the top roller. If you take the

corners of the bottom blanket, gripping them with the *poucettes* to keep them free of ink, the whole pile can be hurled back with a wristy flick and will lie flat and smooth over the upper roller, ready for the next impression. Whichever direction the plank travels, the ends of the blankets are always kept nipped in position, of course. If the tissue paper is lifted separately, it can be put on one side so that at the end of the day's printing, the whole pile of damp tissues can be placed between a couple of sheets of blotting paper and under a board so that when dry they can be used again. The print should be lifted slowly and gently from the plate (see Fig. 7.5). If the paper is jerked clumsily away, fragments of its surface could be left in the plate's crevices, particularly if the ink is especially heavy.

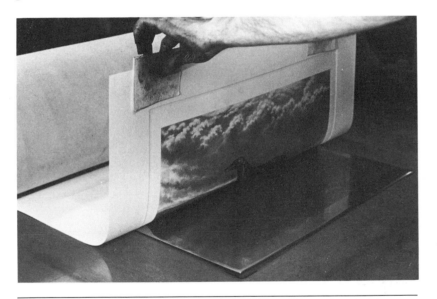

Fig. 7.5 *Lifting the print. Note the printer's use of poucettes, keeping the margins of the print clean*

Drying and flattening prints

Some printmakers dry and flatten their prints by taping the edges to a table top or a large board with gumstrip. However, this has at least three disadvantages: it uses up far too much space; it affects the three-dimensional quality of the print, smoothing out the plate mark and the raised lines of the printing; and, in the case of hand-made papers, it dispenses with the deckle edges, which have to be cut away with the gumstrip. A better way is to interleave the prints with acid-free tissue paper and blotting paper, and put the whole stack between

boards and under a weight. The stack is started by covering a board (a sheet of chipboard or insulation board) with blotting paper on which the first print is placed, face up, and covered with tissue paper. Then the second print with its protective sheet of tissue and, next, another piece of blotting paper. When the whole day's prints have been stacked – blotting paper, two prints covered with tissue, blotting paper and so on – the second board is put on top and, lastly, the heavy weight, and the stack is left undisturbed until the next day (Fig. 7.6). Next day, the top board is removed and the stack is built up again in reverse order, top print at the bottom. This helps to equalise the drying, since the moisture in the paper naturally tends to travel downwards through the pile. During this restacking process, the tissues should be lifted gently away and discarded, since some of the ink from the freshly-pulled prints will have transferred to them. Both the tissues and the blotting paper (though the latter can be dried out and re-used) should be replaced with fresh sheets and, again, the stack is left overnight. After about a week, during which this procedure needs to be repeated two or three times, the prints should be dry and flat enough to be interleaved finally with tissue paper and put away in a drawer or a portfolio. Though tedious and

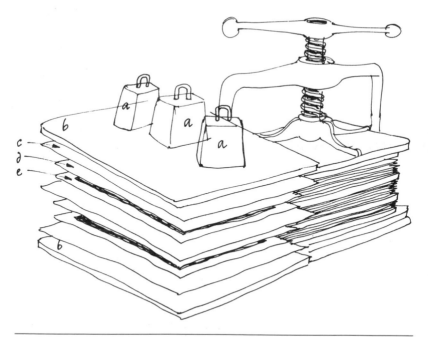

Fig. 7.6 Drying and flattening prints under weights. The boards (b) are of wood or chipboard. Prints (e) may be placed two or three together between the blotters (c), each print covered with a sheet of acid-free tissue paper (d). A bookbinder's press, such as that shown here, is useful for flattening small prints

lengthy, there really is no surer way to dry and flatten prints. It is worth taking trouble over this final phase – prints can so easily be spoiled otherwise. Nineteenth-century plateprinters had special drying houses for this purpose, and at least one still exists and is in daily use at the Leblanc studio in Paris. This little building is in a quadrangle, surrounded by the printing workshops. Narrow-gauge rails run into it from the main studio, so that trolleys laden with prints, boards and damp blankets may be trundled easily into the warm atmosphere. The heat is provided by a coal stove from which a metal pipe runs round the room, spreading the warmth evenly. The room contains wooden racks in which the pressing boards are placed on edge to dry. The wet press blankets are hung on cords overhead, and on low wooden platforms on the floor are stacks of damp prints, sandwiched between boards and weighted with several 20 kg iron weights.

Colour printing

There are various ways of making intaglio prints in colour, but this is a huge subject in itself, so we can do no more than offer a brief description here. The simplest way is to ink the plate as described above, filling all the crevices with ink and wiping the surface. Then, coloured proofing ink (that is, oil-based ink used for relief printing) can be applied thinly to the surface with a hard roller. It is very important that the roller be hard, so that the ink is simply deposited *on* the surface; a soft roller, such as one of gelatine, will tend to enter the crevices. It is also important that the roller be large enough in diameter to cover the plate with one sweep, otherwise the black ink, which it will inevitably pick up from the crevices to some extent, will be transferred to parts of the surface where it is not wanted. After the inking, the plate is printed exactly as described above.

Early in the eighteenth century, a method of intaglio colour printing involving the use of several plates was developed in France. Each plate carried a separate colour, so that when all related plates were printed, one after the other, the superimposed impressions produced the final, full-colour print. This was obviously a very complicated procedure. The etching or engraving of the related plates had to correspond exactly, and another problem would be the tendency of the damp paper to contract as it gradually dried between the printing of the different colours. This method, however, is still used in the Paris studios of Leblanc and Frélaut. Both studios use a system of piercing all related plates with tiny holes in exactly corresponding positions, so that long needles may be used to get precise registration. All the plates are inked, each in its appropriate colour, and printed one after the other on the same sheet of paper

without loss of time, to minimise the shrinking problem. One edge of the paper is kept nipped in the press so that it does not shift, and the sheet is simply laid back over the top roller while the next plate is placed in position on the plank.

Colour printing à la poupée

An interesting method of colour printing still survives at Thomas Ross & Son. It is known as printing *à la poupée* (dolly-printing), and has been in continuous use in Britain at least since the eighteenth century. The plate is first inked with a 'ground colour', the ink worked into the crevices and wiped from the surface in the usual way. This ground colour is usually grey, sepia or some other neutral colour rather than black, which would tend to be too stark. Colours are then applied to the plate's surface with tight little rolls of cotton fabric (called 'dollies', Fig. 7.7) or by means of the printer's finger covered with a muslin rag. The full range of colours is 'painted' on to the plate in this way, and then the whole surface is very delicately wiped with soft muslin so that the frontiers of the various colours are softened. So as not to disturb these colours unduly, there is very little hand-wiping on a plate coloured *à la poupée*. Printing in this way is a highly skilled business. In 1957, Thomas Ross & Son printed an edition from a large mezzotint plate engraved by Lawrence Josset after Annigoni's portrait of HM the Queen. About fifteen colours were applied to the face alone, and there was time for only two impressions a day.

Fig. 7.7 A poupée (dolly) of cotton fabric, for applying coloured inks to a plate

After a day's printing, the pads of muslin should be opened out and hung, ready for use again and again until they become too stiff and clogged. The blankets should be taken from the press and hung separately to dry. Occasionally, if they become stiff with repeated damping and pressure, they may be washed with Lux or some other mild soap. Ink should be carefully cleaned from the plate with cotton rags and white spirit, and stubborn vestiges removed from the crevices with an old toothbrush.

Presenting and studying prints

SIGNING AND NUMBERING PRINTS

It is usual for printmakers to sign their prints in pencil in the margin just below the printed area. You will sometimes also see the letters 'AP', or figures, for example '1/24', in the margin of a print. 'AP' stands for Artist's Proof; the figures '1/24' mean that the particular print so marked is the first of an edition of twenty-four. The second would be marked '2/24', and so on. It is for the individual printmaker to decide how large an edition shall be; anything from 12 to 250 is usual, though editions can be smaller or larger. If an edition of hand-made prints gets too large, however, much of the point would be lost. The idea of keeping a print edition reasonably small is that the owner can be sure he has something which is not reproducible *ad infinitum*. The marginal figure (24 in the case of an edition of twenty-four, for example) is a tacit undertaking that prints will not be made beyond that number. After the whole edition has been made, it is considered ethical to 'cancel' the plate, either by scoring it so that it cannot be used further, or by breaking it up completely. It is accepted that over and above the declared number of prints there will be a small number marked 'AP'. These will usually be the first few proofs made after the printmaker has got the plate exactly as he wants it. Proofs taken earlier, to help him make decisions about developing the image on the plate, are called working proofs.

'STATES'

Autographic printmakers (see p. 8, above) often produce prints in various 'states'. Rembrandt is an excellent example: there exist prints taken at different stages in the development of many of his plates. A comparison of different states of any single plate of Rembrandt's gives a fascinating insight into the workings of his mind. In one state, a composition may contain a group of figures; in the next, the

figures may have disappeared, removed from the plate with scraper and burnisher; and in yet another, the figures may have been reintroduced, differently grouped, larger or smaller in number, or perhaps facing in a new direction. And more often than not, with every new state, Rembrandt produces a completely different effect of light and shadow, subtracting passages of heavy cross-hatching here, adding drypoint there, and so on.

'STATES' IN REPRODUCTIVE PRINTMAKING

All this has its counterpart in reproductive printmaking. We have already seen (p. 36, above) that the typical edition of a nineteenth-century reproductive engraving included Artist's Proofs, Presentation Proofs, Proofs Before Letters, Lettered Proofs and ordinary, or plain, prints. These are also known as states, but you will see that they are not states in the sense in which we apply the word to Rembrandt's work. In the nineteenth-century reproductive print publishing trade, the term was used to denote different phases of the printing, changes of paper and marginal alterations (e.g. to lettering), rather than to indicate modifications to the *pictorial* part of the plate. Old prints are still to be found at a modest price in second-hand shops, and if you intend to collect them (as every serious student of the subject will want to do, sooner or later) it is as well to know how to distinguish the states. What you are *not* likely to find – except, on the whole, in museums – are the very interesting working proofs that were printed from time to time while a plate was being engraved (see Figs. 8.1 and 8.2) and the 'touched proofs', modified by the artist in black and/or white chalk to guide the engraver in the further development of the work (see Fig. 1.9). But you should find plenty of examples of the various states listed above.

Artist's Proofs have a 'publication line' (i.e. the publisher's name, date of publication, etc.) at the top, and are signed in pencil by the artist, usually in the left lower margin. Figure 8.3 shows such a signature; it is that of William Holman Hunt (1827–1910), and it appears on the margin of a proof of an engraving of his celebrated picture 'The Shadow of Death'. Just below the signature is a small embossed oval: this is the stamp of the Printsellers' Association, established in 1847 to regulate the sale of prints in limited editions. Most reputable print publishers subscribed to the Association. Anyone planning to publish would declare his intention to the Association, submitting the following details: title of the work to be reproduced; artist; engraver; style (e.g. line engraving, etching, mezzotint, etc.); size of work (as distinct from size of plate); states (Artist's Proofs, Presentation Proofs, etc.); whether on india paper (i.e. an extremely smooth, fine paper pasted on to a backing of

Fig. 8.1 'Highland Drovers' Departure': detail of an early (etched) state of the engraving (18¾ in by 28⅝ in) by J. H. Watt (the animals etched by William Taylor) after the painting by Edwin Landseer (British Museum, Department of Prints and Drawings)

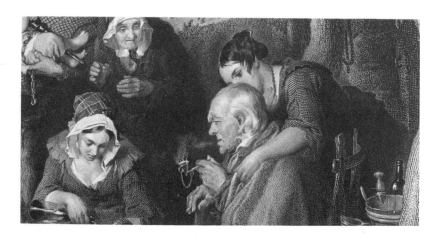

Fig. 8.2 'Highland Drovers' Departure': detail of engraver's proof, 1841 (British Museum, Department of Prints and Drawings)

heavier paper to give it strength) or on plain paper; number and price of impressions in each state; the name of the publisher; and the date of declaration. 'The Shadow of Death' was declared in 1877. The original picture had proved so popular that the unusually high number of 1485 Artist's Proofs – all signed by Hunt – was printed. The price in 1877 was 10 guineas – a high price at a time when

Fig. 8.3 William Holman Hunt's signature in the margin of an engraving
(22⅜ in by 29 in, published 1877) after his painting 'The Shadow of Death'.
Beneath the signature is the stamp of the Printsellers' Association

many workers were bringing home a wage of perhaps a couple of
pounds.

Some nineteenth-century print publishers included in their
editions a small number (customarily twenty-five) of Presentation
Proofs; these were complimentary, for distribution to favoured clients
and friends. In Proofs Before Letters there is usually no publication
line in the margin above the print; instead, it appears beneath the
work, in the centre. The artist's and engraver's names are also
engraved beneath the work: the former at the left, the latter at the
right. Lettered Proofs (Fig. 8.4) have the title of the subject engraved
on the bottom margin; and Prints, or Plain Prints, are presented in
the same way. While all the other states were in limited numbers,
Plain Prints were produced with no restriction: printing simply went
on until the plate became too worn to give respectable impressions.
Sometimes, one comes across what are called Remarque Proofs.
These are proofs with an extra little scene, object or figure etched
or engraved in the margin. This was just a way of creating another
'state', so that publishers could extend their editions still further.

Fig. 8.4 *An engraved title in the margin of a popular mezzotint, 1799*

MOUNTING

Mounting and framing are aspects of printmaking that should be attended to very carefully if prints are to look their best, and if they are to be properly preserved. There are basically two ways of mounting a print: fixing it to the front of a sheet of mounting board; or fixing it behind, so that the printed area is revealed through a 'window' cut in the board. Today, prints on hand-made paper are usually mounted in the first way, simply hinged by the top two corners with gummed tape, which allows the irregular edges, an attractive feature of hand-made paper, to show. However, a window mount has one important advantage: it prevents the glass from coming into direct contact with the surface of the print when framed. In window mounting, it is usual first to fix the print to the front of a sheet of mounting board, as in the simpler method already described. Then, the 'window' (with outer edges of exactly the same dimensions as those of the backing board) is placed in position. It is always cut large enough to reveal the print's plate mark, with a clearance of about half an inch at the top and sides, and about an inch below, to leave room for the printmaker's signature, the edition number, the date, and so on. Mounts look best cut in really substantial board, an eighth of an inch thick or thereabouts. Mounting board of that thickness is difficult to cut accurately, and it is expensive; still, it is worth persevering with the technique of mount cutting, and it is worth buying the best board one can afford. The window in thick mounting board is usually cut bevelled. Once its dimensions have

been lightly marked in pencil, the bevelling is done by holding the knife at a slant while running the blade along the steel straight-edge. All cutting is, of course, done on a sheet of thick cardboard, hardboard or some other suitable surface. It is possible to buy special mount-cutting knives which consist of a sharp blade held at the correct angle in a kind of block which slides across the surface of the mounting board like a plane.

There are exceptions to every rule, but coloured mounts are, on the whole, to be avoided. White or ivory (chosen to harmonise with the paper of the print) are nearly always appropriate; and if a print is considered to be really important, an acid-free variety should be chosen.

STAINING IN PRINTS

The effect of acid in card, paper and other similar substances is all too evident in many old prints. Even those stored carefully in museum print rooms need to be watched for signs of deterioration. The majority of prints found in second-hand shops are stained by both acid and damp. Perhaps the most common form of disfigurement is that scattering of orange-brown speckles known as foxing. This is sometimes quite simply rust – the result of minute particles of metal in the paper. Another form of blemish is the brownish stain rather like a singe; this comes through the print from the thin, resinous panels of wood often used in the nineteenth century – and later – as a backing for the frame. It is very interesting to buy old framed prints and dismantle them to explore the methods used and to try to analyse the damage. They will be found mounted in various ways: some will be pasted flat on to a backing board, and such prints will often be marred by chemicals in the paste; others will be in window mounts to which they are firmly glued all round. Very large prints are frequently stretched like drum skins by having been pasted while damp on to a backing of fine linen on a light wooden frame.

Cleaning stained prints is a job for an expert. Most intaglio prints are made on unsized or very lightly sized paper, and attempts to clean the surface of a stained or dirty print, even with a very soft india rubber, are likely to dislodge the fibres of the paper; the result may be to disfigure the print even more. A prudent restorer may go so far as to gently work a pile of draughtsman's powder (consisting of fine grains of india rubber) across the surface of a line engraving or an etching with a squirrel-hair brush; but he is unlikely to risk even this in the case of a delicate aquatint or a mezzotint.

Bleaching is hazardous, and anyone wishing to experiment with this method of cleaning a print should consult a specialist journal

such as *The Paper Conservator* (obtainable from the Institute of Paper Conservators, PO Box 17, London WC1). The safest way to improve the appearance of a dirty print is simply to wash it in clean water. Even so, very flimsy paper is best left alone, since it can easily disintegrate when wet; and long immersion of an india proof could lift the india paper from its backing of heavier paper. Usually, though, if a sheet of paper feels quite firm and robust it may be washed without danger. A tray to accommodate even the largest print may be made by stretching heavy duty polythene on a wooden frame about two inches deep. A separate sheet of polythene, slightly larger than the print to be cleaned, should be placed at the bottom of the tray before filling it with water. The print should then be lowered into the tray and left for about an hour. On no account should the submerged surface be rubbed or brushed. Then, the print should be very gently lifted out of the water, using the separate sheet of polythene as a support, the water allowed to drain from it, and should be placed on a clean blotter. The surface may then be lightly dabbed with another blotter, and the print can finally be dried and flattened in the way described on p. 90.

FRAMING

Getting the framing right is extremely tricky: frame and print must harmonise. Many present-day printmakers solve the problem by placing their prints between thin, rigid board and a sheet of glass, holding the sandwich together with small metal clips. Others use simple, slender aluminium or brass mouldings, right-angled in cross-section. Victorian engravings were commonly framed in flat oak mouldings, and modern prints can look very handsome in similar frames, especially if the oak is light in colour and the moulding not too heavy. Old oak frames look very unprepossessing when dull and dusty; but they can be extremely beautiful if cleaned with fine wire wool dipped in a half and half mixture of linseed oil and white spirit. Sometimes, these old prints are to be found in frames encrusted with battered plaster and gilding; it is worth getting a wood-stripping firm to remove this, since there is often a pine moulding under all the wreckage, and its splendour can easily be restored with glasspaper and wax polish.

STUDYING PRINTS

As in all forms of visual art, *looking* is the vital thing. Only careful and persistent looking will pave the way to understanding. A sure

way to develop an understanding of your own work is to try and see it in the context of the work of others. So, closely studying all the examples of print that you come across is a good habit to get into, and if a museum with a print collection is not accessible, then the

Fig. 8.5 Detail (c. 3 in by 2 in) of 'The Doctor', photogravure (20¼ in by 29½ in) of the painting by Luke Fildes. Published 1892

local second-hand shops will be an excellent substitute. In fact, studying prints in that setting can be valuable training in that you *have* to use the evidence of your eyes – there is seldom any convenient labelling to help you out. On such excursions, you will soon learn to distinguish hand-made prints from their photo-mechanical equivalents. Gradually, some kind of pattern will emerge. For example, if you are lucky enough to come across any pure mezzotints, you will find that they are likely to date from the late eighteenth century, and that most of them will be portraits. Many of the aquatints you discover will date from the 1820s and 1830s, and will be of sporting subjects. Pure line engravings will be found on the whole to date from between about 1830 and 1850, though now and again one finds much earlier examples. Engravings incorporating mezzotint and a variety of other methods will probably have been produced between the 1840s and the 1880s. Very many etchings will be the products of what is known as the 'etching revival', and will have been made between the 1880s and the 1920s. And the earliest examples of photogravure (a photographic engraving technique which signalled the beginning of the end of hand reproduction, Fig. 8.5) will date from the 1890s.

It is not quite so easy to suggest a pattern for twentieth-century printmaking in general. At one end of the scale, some modern printmakers use traditional methods which have remained virtually unchanged for centuries; others take full advantage of the technological innovations which have in recent years revolutionised the craft of printing; and many use old methods and new in exciting combination. The basic principle of intaglio printmaking, though, is unaltered and its deep roots in history are clearly evident.

Supplies

General intaglio printing materials

The following firms supply tools, inks, paper, plates, blankets, wiping canvas, varnish, wax grounds, aquatint materials etc. All will provide catalogues and price lists on request:

L. Cornelissen & Son
22 Great Queen Street
Covent Garden
London WC2

Intaglio Printmakers
20–22 Newington Causeway
London SE1

T. N. Lawrence & Son Ltd
2–4 Bleeding Heart Yard
Greville Street
Hatton Garden
London EC1

Michael Putnam
151 Lavender Hill
London SW11

Roberson & Co. Ltd
77 Parkway
London NW1

Paper suppliers

All the following firms supply a wide range of papers, tissues and mounting boards:

Atlantis Art
Gulliver's Wharf
105 Wapping Lane
London E1
(suppliers of Heritage Book White)

Barcham Green
Hayle Mill
Maidstone
Kent

R. K. Burt
37 Union Street
London EC1

Falkiner Fine Papers
117 Long Acre
London WC2

Grosvenor Chater & Co. Ltd
Brick Knoll Park
Ashley Road
St Albans
Herts
(suppliers of Cornwall Cover Paper)

Printers' engineers

Both these firms will supply second-hand presses (when available)
and will undertake transport and repairs. Harry Rochat also makes
new presses:

Modbury Engineering
Belsize Mews
27 Belsize Lane
London NW3

Harry Rochat
Cotswold Lodge
Stapylton Road
Barnet
Herts

Suppliers of cleaning rags

Cleaning Waste
Homecroft Works
Homecroft Road
London N22

Steel-facing specialists

Thomas Ross & Son
5 Manfred Road
Putney
London SW15

Bibliography

The bibliography is arranged under the following headings:
Resources; Techniques; History; Paper; Ink; Collecting and care of
prints. Titles in each section are presented in chronological order of
publication.

Resources

Turner, S. (1977) *Handbook of Printing Supplies*. Printmakers'
Council, London.
This is an extremely valuable publication, containing a great deal
of detailed information on suppliers of relief, screen and
lithographic printing as well as intaglio printing materials and
equipment. The author also lists the addresses of studios and
workshops.

Techniques

Bosse, A. (1645) *Traicté des Manières de Graver en Taille-Douce*. Paris.
This book, like all the other early publications listed here, will need
to be consulted in a specialist reference library, such as that at the
Victoria & Albert Museum, London. It is very rewarding,
however, to seek out such early accounts of the craft. This book is
most interesting for the illustrations alone (see, for example,
Fig. 6.3, above).
Partington, C. F. (*c.* 1825) *The Engraver's Complete Guide*. London.
Full of information on technological advances in the intaglio
printing trade in the early nineteenth century.
Berthiau and Boitard (1836) *Nouveau Manuel Complet de l'Imprimeur
en Taille-Douce*.
Another book worth tracking down for the information contained
in its illustrations (see, for example, Figs. 2.13 and 6.10, above).

Fielding, T. H. (1841) *The Art of Engraving*. London.
 In addition to very full and careful accounts of all the intaglio
 processes, this book contains interesting pages of advertisement
 listing contemporary tools and materials, with prices.
Haden, S. (1878) *About Etching*. Strangeways, London.
Herkomer, H. (1892) *Etching and Mezzotint Engraving*. London.
Frankau, J. (1906) *Eighteenth Century Colour Prints*. London.
 The book contains a fascinating account of full-colour printing
 from a single plate.
Prideaux, S. T. (1909) *Aquatint Engraving*. Duckworth & Co.,
 London.
Hardie, M. (1910) *Frederick Goulding, Master Printer of Copper Plates*.
 London.
Strang, D. (1936) *The Printing of Etchings and Engravings*. Benn,
 London.
Buckland-Wright, J. (1953) *Etching and Engraving: Technique and the
 Modern Trend*. Studio, London and New York.
Hayter, S. W. (1962) *About Prints*. Oxford University Press.
Lumsden, E. S. (1962) *The Art of Etching*. Dover, New York.
 This is a reprint of the work first published in 1924. The book
 contains highly detailed accounts of such important aspects as
 damping paper, preparing inks and the composition of acids.
Trevelyan, J. (1963) *Etching*. Studio, London and New York.
Hayter, S. W. (1966) *New Ways of Gravure*. Oxford University Press.
 Both this and Hayter's earlier work (1962) integrate history, theory
 and technique. Both books are particularly effectively illustrated.
Bayard, J. and D'Oench, E. (1976) *Darkness into Light: the Early
 Mezzotint*. Yale (catalogue).
 One of the clearest published accounts of the process.
Clifford, Griffiths and Royalton-Kisch (1978) *Gainsborough and
 Reynolds in the British Museum*. British Museum, London
 (catalogue).
 The work contains valuable accounts of the engraved reproductions
 of the pictures of both artists. It gives an especially good insight
 into the print publishing trade in the late eighteenth century.

History

Landseer, J. (1807) *Lectures on the Art of Engraving*. London.
Raimbach, M. T. S. (1843) *Memoirs and Recollections of Abraham
 Raimbach*. London.
 Abraham Raimbach (1776–1843) was an engraver who reproduced
 the pictures of such celebrated artists as Sir David Wilkie. His
 memoirs give an intriguing glimpse of the art world of his time.

Tuer, A. W. (1882) *Bartolozzi and his Works*. London.
The title does less than justice to the scope of the book. As well as biographies of Bartolozzi and his pupils, it contains descriptions of stipple engraving and other intaglio processes, and a great deal of information on the leading London plateprinters of the nineteenth century.

Hind, A. M. (1963) *A History of Engraving and Etching*. Dover, New York.
This is a reprint of the 1923 (3rd) edition of Hind's colossal work, based on many years of study of the British Museum's print collection.

Bain, I. (1966) 'Thomas Ross & Son, Copper- and Steel-Plate Printers since 1833', *Journal of the Printing Historical Society*, No. 2. London.

Beck, H. (1973) *Victorian Engravings*. Victoria & Albert Museum, London (catalogue).

Maas, J. (1975) *Gambart, Prince of the Victorian Art World*. Barrie & Jenkins, London
The biography of Gambart, a Belgian immigrant prominent as a picture dealer and print publisher in London in the nineteenth century, provides the framework for a stimulating account of the interdependent careers of artists, engravers, dealers and their patrons.

Dyson, A. (1977–78) 'The Ross Records', *Journal of the Printing Historical Society*, No. 12. London.

Dyson, A. (1983) *Thomas Ross & Son, Fine Art Printers: the Nineteenth Century Heritage*. Ross, London.

Dyson, A. (1984) *Pictures to Print*. Farrand Press, London.
These last three works (like that of Bain, 1966) deal with the history of a firm still in existence after 150 uninterrupted years in the plate printing business. The firm holds an enormous stock of plates (after such artists as Edwin Landseer, Charles Eastlake and many others of the eighteenth- and nineteenth-century British School), proofs and written records, and is thus an extremely important repository of evidence.

Paper

Balston, T. (1954) *William Balston, Paper-Maker (1759–1849)*. London.

Evans, J. (1955) *The Endless Web: John Dickinson & Co, Ltd., 1804–1954*. London.

Balston, T. (1957) *James Whatman, Father and Son*. London.

Ink

Wiborg, F. B. (1926) *Printing Ink*. London and New York.

Bloy, C. (1967) *A History of Printing Inks, Balls and Rollers, 1440–1850*. London.

Collecting and care of prints

Zigrosser, C. and Gaehde, C. (1965) *A Guide to the Collecting and Care of Original Prints*. Acro, London.

Index

Italic page numbers refer to Figures